IMAGES
of America

RAILWAYS
AND
WATERWAYS
THROUGH THE WHITE MOUNTAINS

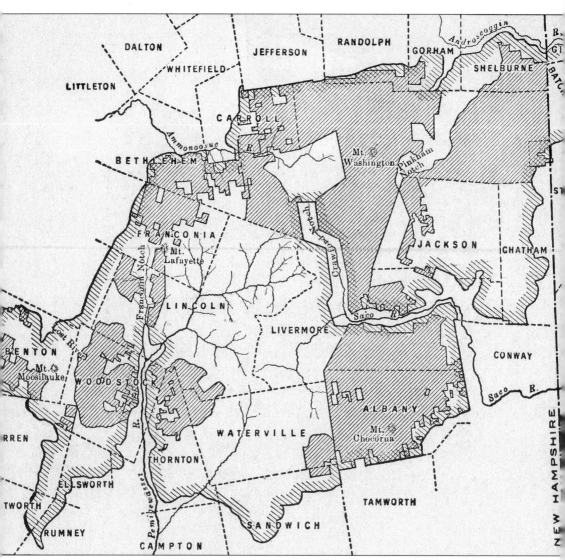

A Map of the White Mountain National Forest, early 1900s. The complete reservation, as originally planned by the National Forest Reservation Commission (approximately 698,000 acres), is shown by the shaded boundary line. The total territory acquired to date (September 1998) amounts to 728,150 acres, inclusive of New Hampshire and Maine.

The White Mountain National Forest Reserve was established in 1911 after public outcry forced passage of the Weeks Act, allowing the federal government to purchase private land east of the Mississippi River. Before establishment of the National Forest, the land had been ravaged by uncontrolled logging and fires that raged across the landscape. The National Forest was established in 1918 by a Presidential proclamation.

IMAGES
of America

RAILWAYS
AND
WATERWAYS
THROUGH THE WHITE MOUNTAINS

Bruce D. Heald, Ph.D.

ARCADIA

Published by Arcadia Publishing,
an imprint of Tempus Publishing, Inc.
2 Cumberland Street
Charleston, SC 29401

Printed in Great Britain.

Library of Congress Catalog Card Number: 99-60796

For all general information contact Arcadia Publishing at:
Telephone 843-853-2070
Fax 843-853-0044
E-Mail edit@arcadiaimages.com

For customer service and orders:
Toll-Free 1-888-313-BOOK

Visit us on the internet at http://www.arcadiaimages.com

To my students, who have inspired and enriched my life.

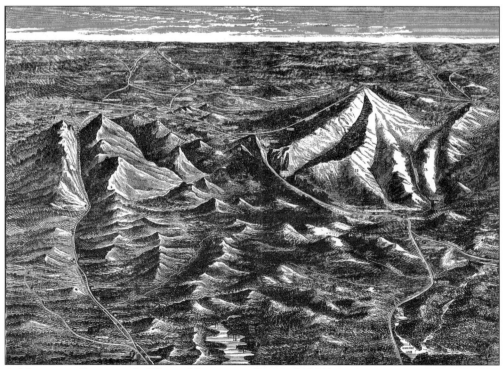

A MAP FROM CHISHOLM'S *WHITE MOUNTAIN GUIDE* (1880).

CONTENTS

ACKNOWLEDGMENTS

I would like to thank the following people and organizations: John Anderson, the Appalachian Mountain Club, Marling P. Billings, the Boston & Maine Railroad Co., Alexander A. Bright, the Sterling and Francine Clark Art Institute, Chisholm Bros., the *White Mountain Guide*, Howard M. Cook, the Concord & Montreal Railroad Co., Charles E. Crane, John Creasy, the Dartmouth Outing Club, John Dickerman, Mike Dickerman, the *Granite State Monthly*, Donald N. Henderson, Kenneth A. Henderson, Hunting Studio, the International News Service, the U.S. Department of Interior, Robert and Mary Julyan, Thomas Starr King, the Lakes Region Association, Steve Lantos, Robert Lawton, Stearns Morse, the Mount Washington Observatory, Inc., John T.B. Mudge, the NH Highway Department, the NH Historical Society, the NH Planning & Development Commission, the NH Department of Resources and Economic Development (DRED), Oakes' *White Mountain Scenery*, James R. Osgood & Co., Osgood's *American Guide Book*, Harold Orne, Ruth Page, Roderick Peattie, A.E. Phinney, Charles Pollock, Winston A. Pote, W.C. Prime, Christine L. Reid, Karl Roenke (White Mountain National Forest), Greg Sagris, George Slade, Dick Smith, Steven D. Smith, the Society for the Protection of New Hampshire, I. Sprague, H.B. Washburn, Noel T. Wellman, Cornelius Weygandt, *The Weirs Times, Inc.*, Merle Whitcomb, the White Mountain National Forest, the Winnipesaukee Flagship Corp. Frank Wood, Arthur W. Vose, and all those friends who have assisted in making this volume possible.

INTRODUCTION

New Hampshire is a state reclining with its head pillowed on high mountains and its feet washed in its many waterways—the majestic White Mountains.

The charm of the White Mountains is its infinite variety of scenery, inexhaustible in its resources and unlimited in its manifold combinations. Each of the villages and glens command the magnificent aspects of the many ranges. Every mile of approach opens a new series of prospects, each of which has its own peculiar attractiveness, and reveals the natural grandeur of its landscape.

The element of color in this region appears in manifold variety and brilliance, not only with the seasons but with the changing hours of the day. The different lithological formations of the mountain ranges also call forth admiration in their scenic beauty; the brilliant hues of the Presidential Range contrasting with the unbroken blackness of Sandwich Dome and the blanched crests of Whiteface and Chocorua. They all give rise to the most magnificent display of color when the early frost of autumn and the full ripening of their leaves combine to produce the matchless pageantry of gold, scarlet, and tan in which the highlands are arrayed. In respect to the lakes and mountain streams, scattered through the glens and reflecting the storm-beaten peaks above, they too bring alive the pulse of our forest via the navigable Pemigewasset, Saco, and Ammonoosuc, with its pure water within sight of their highest crests.

Reminisce for a moment when railroad was king of transportation during the late 1800s, as if we were on the Ogdensburgh Railroad traveling from the Conways through a picturesque Saco River Valley and Crawford Notch, or the Boston & Maine Railroad up the stately, pastoral Pemigewasset Valley to Franconia Notch, or maybe over the highlands along the Ammonoosuc River to Fabyan's and the base of the Presidential; all views rendered a magnificent

vista of conspicuous summits, and undaunted lakes and rivers.

There is a special gift of wonderment as we witness the harvest of 112,000 acres of designated wilderness. The forest itself encompasses nearly 800,000 acres of landscape ranging from hardwood forest to the largest alpine area east of the Rocky Mountains and south of Canada.

This beautiful National Forest was established in 1911 to provide resources for the nation while also protecting and managing the land for future generations. Here in the White Mountains we may enjoy not only its seasonal beauty, but its winter skiing, summer hiking, camping, and water activities with the entire family.

Through this rare photographic journey, I have attempted to capture some brief moments of the romance, charm, and nostalgia of the character of the mountains, rivers, and lakes so as to preserve in print the spirit and majesty of the White Mountains and its waterways by rail.

Bruce D. Heald, Ph.D.

One

THE PEMIGEWASSET VALLEY

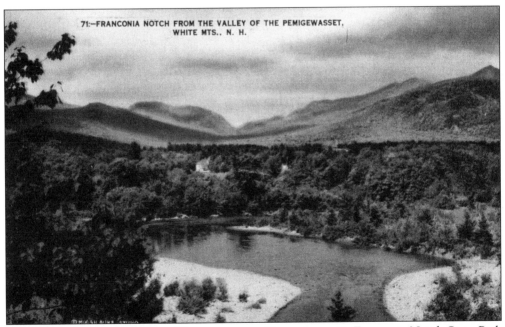

FRANCONIA NOTCH FROM THE VALLEY OF THE PEMIGEWASSET. Franconia Notch State Park covers approximately 600 acres along both sides of the Pemigewasset River for 8 miles. Here are located waterfalls in greater numbers than in any other area of equal extent in the White Mountains. The views along the Appalachian Trail over Mt. Lincoln and Mt. Lafayette are breathtaking, especially along the "knife-edge," where sheer cliffs fall away on each side. The natural beauty of this park is magnificent and majestic beyond words.

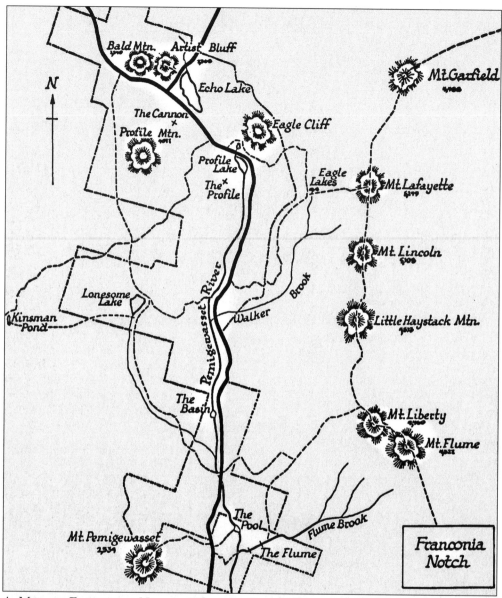

A Map of Franconia Notch. What the Saco Valley is to the White Mountains, the Pemigewasset Valley is to the Franconia Range, the long and delicious vestibule through which access is gained to the many shadowy hills at the end. The name itself breathes forth the free spirit of nature, and sounds like the long rustle of pine-boughs, or the rush of sylvan streams through dewy thickets. It is one of those ponderous words that Native Americans could make as well as modern German philosophers, and it means "Crooked-Mountain-Pine-Place." Born in Profile Lake and re-enforced by long streams from the wilderness about Thoreau Falls, this sesquipedalian stream known as the Pemigewasset descends 1,500 feet in the first 30 miles of its course, filling the lovely valley with music and coolness, and fructifying leagues of level green intervales.

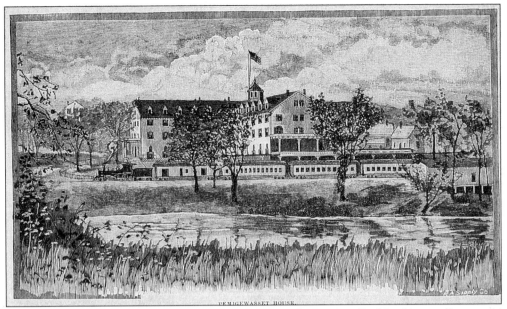

PEMIGEWASSET HOUSE.

THE PEMIGEWASSET HOUSE AND THE BOSTON, CONCORD & MONTREAL RAILROAD STATION, PLYMOUTH, 1877. There are numerous "gate-ways" to the White Mountains, but none are more attractive then the valley of the "Winding Water among the Mountain Pines," which is the interpretation of the Native-American name for the Pemigewasset Valley. In 1850 the Boston, Concord & Montreal Railroad completed the road to Plymouth from Concord. In 1858 the BC&M leased the White Mountain Railroad, thus continuing the road from Plymouth to Littleton. In 1869 the construction of an extension of the White Mountain Railroad beyond Littleton was undertaken, and in 1872 the track from Wing Road toward the base of Mt. Washington was begun.

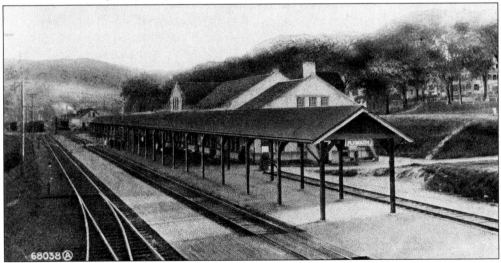

THE PLYMOUTH RAILROAD STATION, 1930s. At the foot, or the opening from the south, of the Pemigewasset Valley stands the town of Plymouth, NH, containing the old courthouse in which Daniel Webster made his first plea. But perhaps the town itself was as well known to travelers because of its great hotels, at once a hostelry and a station, along whose porticoes the railroad stretched, and in front of which, within a short stone's throw, the river runs.

11

THE CONFLUENCE OF BAKER'S RIVER AND THE PEMIGEWASSET RIVER. Leaving the main line of the White Mountain Division, the "P.V." Branch follows the river into a delightful country of quaint villages, majestic mountains, and streams. The earliest records (1712) indicate that Governor Joseph Dudley in Boston suggested, ". . . sending of an expedition of 40 men to Coassett" (Coos). Captain Thomas Baker was selected as commander of the expedition to explore Coos County. Baker and his men followed the course of the Connecticut River to Haverhill, and turning east, proceeded down the Asquamchumauke River to Plymouth. Just above the junction of this river with the Pemigewasset (the Ox Bow), the expedition encountered a band of Native Americans; a brief skirmish followed without loss of life to the explorers, though several natives were reported dead. The Asquamchumauke River was later named Baker's River.

INTERVALE, THE LAND NORTH OF PLYMOUTH, LOOKING THROUGH THE BAKER RIVER VALLEY. Hundreds of acres of rich alluvial soil are located here in the valley. The river flows southeasterly from Wentworth to the north of Plymouth, NH, where it joins with the Pemigewasset. Native Americans referred to this river as "Asquamchumauke," meaning "Salmon Spawning Place" and "Water of the Mountain Place." The name Pemigewasset is an Abenaki word meaning "Rapidly Moving." Stinson Mountain (alt. 2,900 feet) rises at the extreme left and the placid waters of Loon Lake are spread at its foot. Mt. Tecumseh (alt. 4,003 feet) and Sandwich Dome (alt. 3,980 feet) form a more central part of the horizon.

12

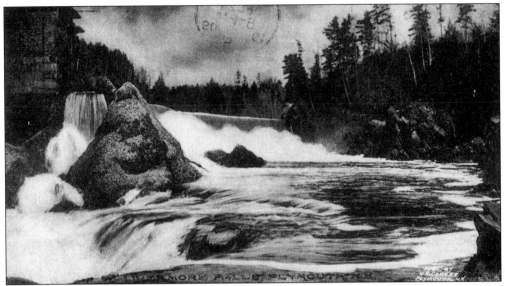

LIVERMORE FALLS IN HOLDERNESS. Logging was a major industry in the area, but sawmills also dotted the shores of most waterways throughout the lakes and mountains. This spot is mostly admired by the anglers, for trout and some of the most beautiful specimens of land-locked salmon can be caught at these falls.

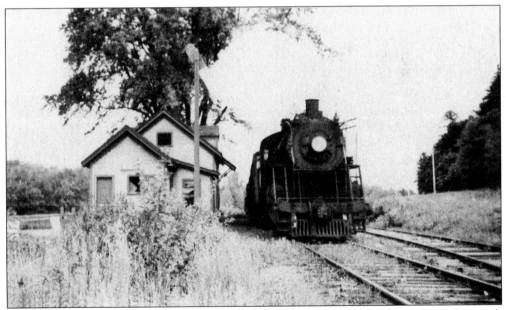

BLAIR'S STATION, CAMPTON, 1930. This was a flag station near Blair's Hotel, 4 miles north from Plymouth, 55 miles from Concord, and 130 miles from Boston. The name of Campton always recalls a picture of shining stretches of river, winding through restful meadows and charming intervales, dotted with beautiful elms and maples.

13

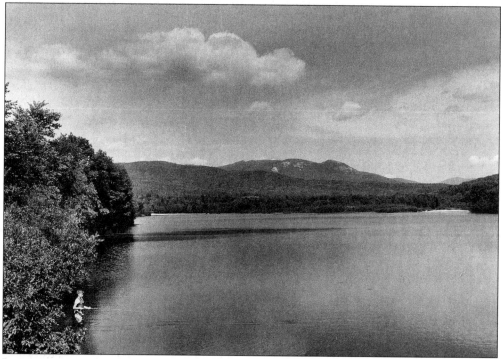

LOOKING ACROSS CAMPTON POND, AUGUST, 1954. A young fisherman tries his luck in a lake created when a dam was built to impound this water in 1935 by the CCC.

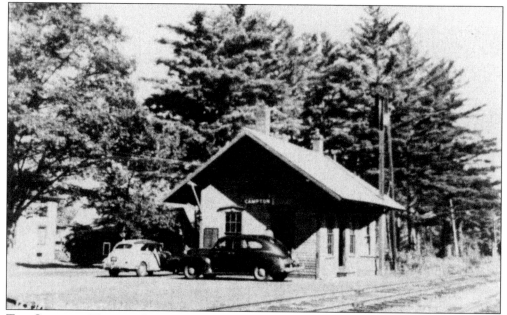

THE CAMPTON VILLAGE STATION, 1947. This was the chief station in the town of Campton, 7 miles from Plymouth, 58 miles from Concord, and 133 miles from Boston. Waterville Valley and Mad River are 10 miles north of this station. Carriages met passengers and carried them to the valley, passing Welch Mountain north of Mad River. Up the Mad River Valley, Tripyramid and Sandwich Dome can be seen.

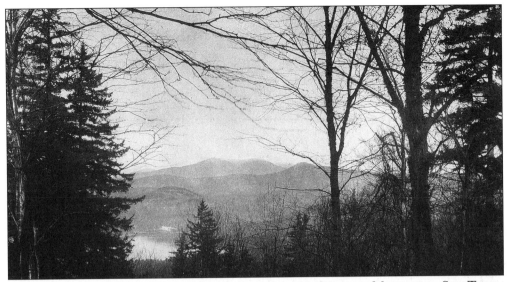

STINSON LAKE (ALT. 1,303 FEET), SEEN FROM THE STINSON MOUNTAIN SKI TRAIL, RUMNEY. This small body of water is surrounded by hills and dominated by Mt. Stinson (alt. 2,900 feet). The lake, brook, and mountain all perpetuated in their name in April 1752 from David Stinson of Londonderry, one of General John Stark's company, who were the first white men to visit the region. While on a peaceful hunting expedition, they were attacked by a party of 10 Native Americans under Chief Francis Titigaw. Stinson was killed and scalped on the shore of this lake; General Stark was captured and taken to Canada, but was later released.

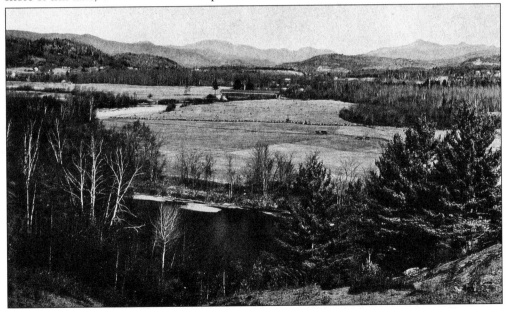

THE FRANCONIA MOUNTAINS AND THE PEMIGEWASSET VALLEY FROM WEST CAMPTON, 1920s. Here is the southern end of Franconia Notch, which is about 6 miles in length. Within the deep cut between the mountains of the Franconia Range on the east and those of the Kinsman Range on the west are such natural wonders as the Flume, the Pool, the Basin, the Profile of the Old Man of the Mountain, Profile and Echo Lakes, and the beginning of a charming stream, the Pemigewasset.

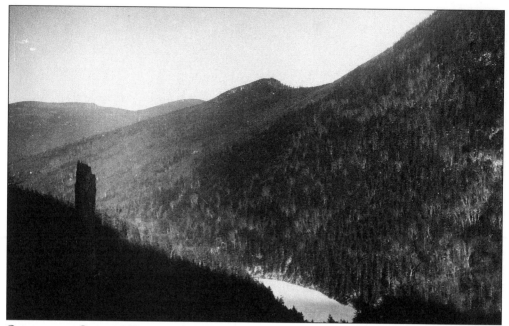

ONE OF THE GREELEY PONDS FROM NATURE TRAIL-MAD RIVER, MT. KANCAMAGUS. The Greeley Ponds are located in a deep and narrow notch between the east slope of Mt. Osceola (alt. 4,340 feet) and Mt. Kancamagus (alt. 3,763 feet) in the Mad River Notch. The upper pond consists of 2 acres; the lower one is slightly larger, consisting of 3 acres. Fishermen still visit these waters in quest of trout, though better sport may be found on the larger tributaries of Mad River.

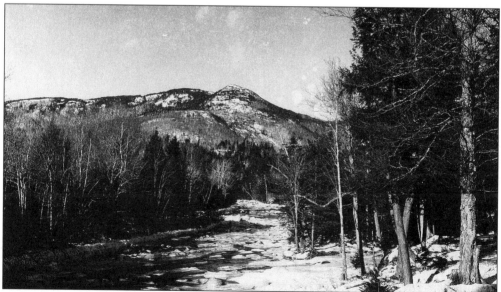

LOOKING UP MAD RIVER, WATERVILLE VALLEY, MAY 1937. This river is located in the heart of the mountainous Mad River district. At this point the Mad River Valley ends, for the glen is nearly surrounded by tall and formidable mountains. The vast walls of the valley are composed of Mt. Tecumseh (alt. 4,003 feet), Osceola (alt. 4,340 feet), Tripyramid (alt. 4,140 feet), and Black Mountain (alt. 2,732 feet), or Sandwich Dome.

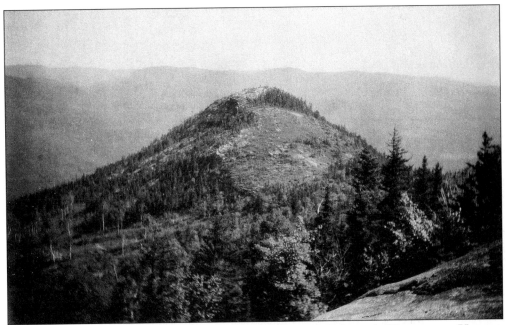

MT. WELCH (ALT. 2,605 FEET) FROM MT. DICKEY (ALT. 2,734 FEET), WATERVILLE VALLEY.
Mt. Welch is a lofty spur of the Tecumseh Range, which is connected by a nearly level ridge curving about the head of a deep and wooded ravine. The greater part of its flanks are composed of granite (porphyritic), reaching the surface in long and slanting ledges, often of convex outline, and affording an interesting display of Nature's ability as an architect. The summit rises like a rude dome from the long terrace below and is attained by flanking two lines of cliffs (alt. 3,500 feet).

MT. OSCEOLA (ALT. 4,340 FEET) AND EAST PEAK (ALT. 4,156 FEET) FROM THE UPPER DRAKE FARM FIELD ALONG THE MAD RIVER ROAD, WATERVILLE. Mt. Osceola is flanked on the east by a bold secondary peak, overhanging the Greeley Ponds, and a line of picturesque summits trends off in the opposite direction toward the East Branch. The view from the summit is equal to that from Mt. Carrigain (alt. 4,700 feet) or Mt. Willey (alt. 4,285 feet) for its wide sweep over the Pemigewasset Forest and the surrounding peaks.

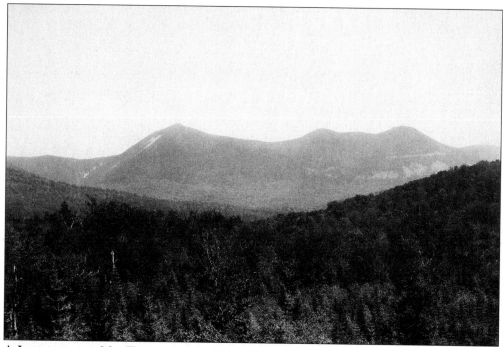

A LANDSLIDE ON MT. TRIPYRAMID (ALT. 4,180 FEET), 1885. The bold ridge of Tripyramid, with its three peaks, is shown here; on its side is the long and sinuous white line of the Great Slide as seen from the Waterville Golf Links. At the foot of the slide is the old clearing of Beckytown, long since deserted. The dark and wooded crest of Whiteface Mountain (alt. 4,020 feet) is located over the south slope of the mountain.

THORNTON STATION, 1917. This flag station is situated 9 miles above Plymouth. The Mill Brook Cascades are located in the town and can be visited either from this point or from Campton Village. Thornton, which extends along the valley, was well known for its prosperous farms and boarding houses.

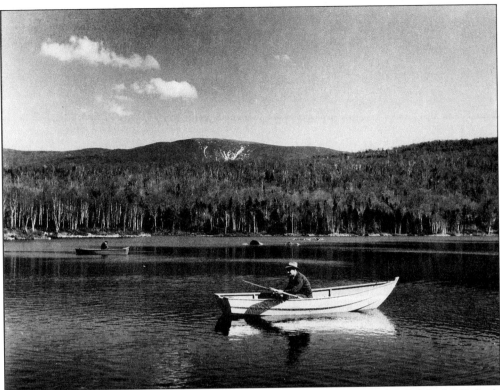

LONG POND, MAY 1939. Located between the Benton Range and Mt. Clough (alt. 3,561 feet), Long Pond has an area of 124 acres. Trout fisherman enjoy their sport near its outlet. Mt. Moosilauke (alt. 4,802 feet) can be seen in the background.

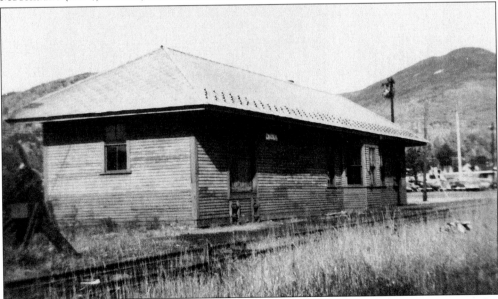

LINCOLN. The Pemigewasset Valley Branch ends at Lincoln, that hustling "city of the woods." From Lincoln a visitor could take a stage line connecting with trains at North Woodstock for the entrance to the Flume, and through Franconia Notch.

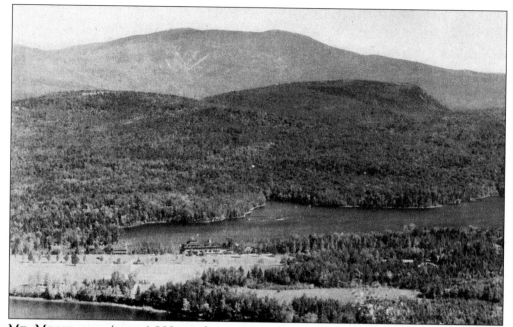

MT. MOOSILAUKE (ALT. 4,802 FEET) AND LAKE TARLETON. On the main line, north from Plymouth, is Warren, the first station of importance as a summer resort. Five miles from the station rises the grand old mountain peak of Moosilauke—the only great mountain this side of the White Mountain Range. This mountain is composed of a high and pointed south peak and a broad plateau on the north, joined by a narrow ridge and flanked by wooded foothills. It is separated from the Blue Ridge by the gorge in which rises Baker's River, and from Mt. Clough (alt. 3,561 feet) on the northwest by a low and traversable pass. On the east side of the mountain is a deep gorge known as the Jobildunk Ravine, where the Seven Cascades are located. This ravine is considered one of the wildest places in the state; due to its thick forest, it is difficult to hike.

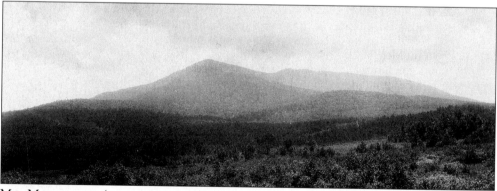

MT. MOOSILAUKE (ALT. 4,802 FEET) FROM THE WILDWOOD RAILROAD STATION ON THE LOST RIVER HIGHWAY. The Native-American name "Moosilauke" means "Bald Place." The sunrise and sunset views from Mt. Moosilauke rival those from the summit of Mt. Washington. This mountain has the highest elevation in New Hampshire west of Mt. Lafayette. On Belknap's map of 1791 it was originally named Mooshelock. Due to its isolation, and because fog and clouds rarely settle here, Moosilauke allows one of the best views in the state, giving a noble grouping of the Franconia and White Mountains as well as overlooking the rich Connecticut Valley.

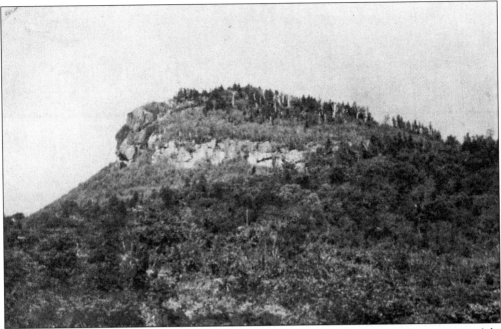

THE INDIAN HEAD PROFILE. This profile is situated on a rocky ledge on Mt. Pemigewasset (alt. 2,557 feet) at the southern end of Franconia Notch on the western side of Route 3.

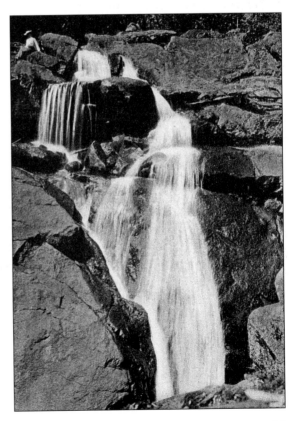

GEORGIANA FALLS, NORTH WOODSTOCK. The falls, located on Harvard Brook, are also known as Upper and Lower Georgiana Falls.

21

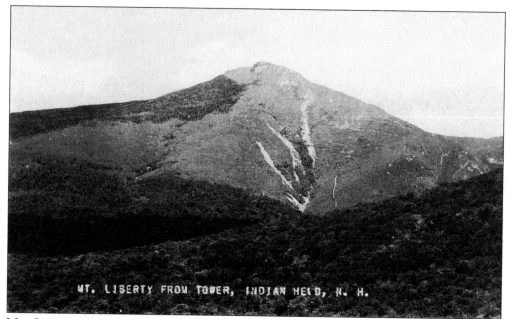

MT. LIBERTY (ALT. 4,459 FEET) FROM THE TOWER AT INDIAN HEAD. This mountain is located south of Mt. Lincoln (alt. 5,089 feet) and the haystack "The Nubble" (alt. 2,713 feet). Its summit is located 3-4 miles from the Flume, over a very rugged route. The peaks on the ridge were named haystacks because they resembled piles of hay when seen from the town of Lincoln, to the south.

MT. LIBERTY (ALT. 4,459 FEET) FROM THE FLUME POOL PATH DURING THE WINTER.

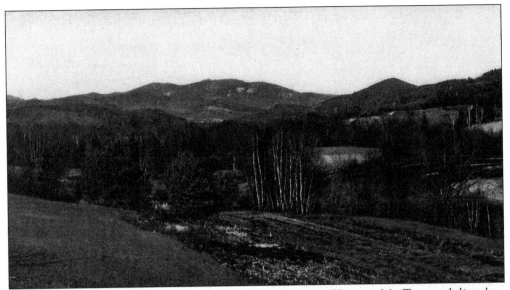

MT. TECUMSEH (ALT. 4,003 FEET) AND THE PEMIGEWASSET VALLEY. Mt. Tecumseh lies close to Osceola (alt. 4,340 feet) on the southwest, being separated from it by a deep and tangled ravine. Its summit is composed of a steep and lofty pile of white rocks, inaccessible on two sides, rising to a pronounced peak, forming one of the most interesting sections of natural architecture in the region. Looking northwest from its summit across the great trough of the Pemigewasset Valley, a 12-mile distance, the long and lofty ridge of Mt. Kinsman (alt. 4,358 feet) can be seen, flanked on the right by the sides of Cannon Mountain (alt. 4,100 feet), and with Mt. Pemigewasset (alt. 2,557 feet) in the foreground.

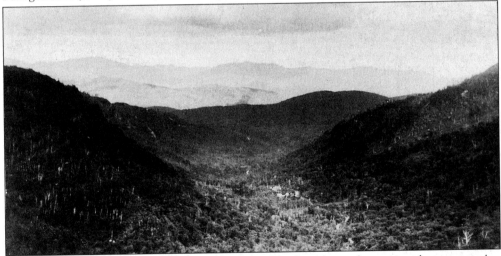

KINSMAN NOTCH, LOST RIVER. This notch received its name from an early pioneer, Asa Kinsman, who hewed his way through the notch with an ax rather than turn back when he found himself on the wrong road. He is said to have come from the south, with his wife and household goods piled on a two-wheeled cart pulled by a yoke of oxen, bound for Landall to take up a land grant. When they arrived at Woodstock, they found they were on the wrong track and discovered that Landaff was beyond the lofty mountain, 9 miles farther northwest. Undaunted, Asa, with the aid of two strangers, proceeded to cut his way through the forest to reach the settlement, where they made their home.

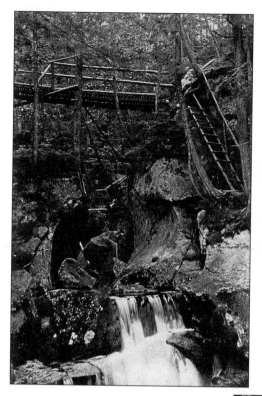

LOST RIVER, 1916. It is recorded that some 50 years after Kinsman hewed his way through the notch, two boys, Royal and Lyman Jackson, went fishing there. Suddenly, according to Royal, Lyman disappeared "as though the earth had swallowed him." He had dropped down a dozen feet through a hole into a waist-high pool. Badly frightened but unhurt, he was rescued by Royal. Years later, Royal came back to North Woodstock to visit, and with a group of boys found his way through the woods to the present Cave of Shadows. This, the old man declared, was where he and his brother found "the Lost River."

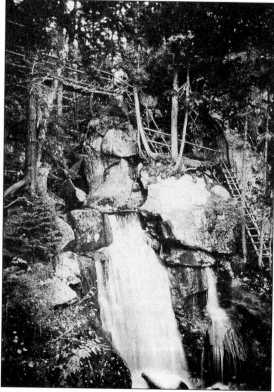

PARADISE FALLS, LOST RIVER. The Lost River probably derived its name from the fact that the Moosilauke River has a way of losing itself here and there beneath huge rocks, riven by frost from the side of the mountain to the north.

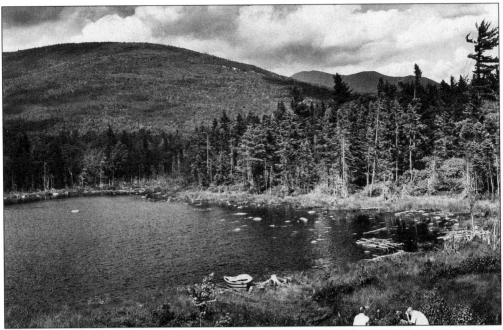

Little Lily Pond. This pond, surrounded by fir and spruce, is located beside the Kancamagus Highway between Lincoln and Conway. It has an area of 4 acres.

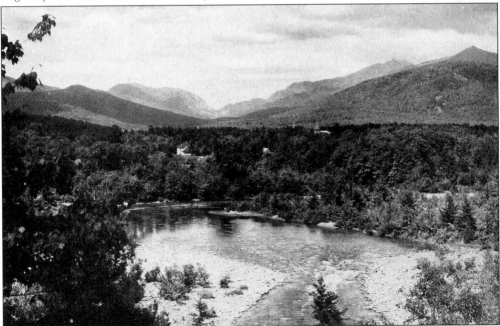

Franconia Notch from North Woodstock. Geologically, the notch is an impressive example of early glacial action. The pre-glacial stream valley had approximately the same position as the headwaters of the present Pemigewasset River, but was not so deep and the slopes were much rounder. The ice moving through the notch gradually over-steepened them to produce Eagle Cliff and the cliff of Profile Mountain (alt. 4,100 feet). The floor of the original valley was also worn down, perhaps by several hundred feet.

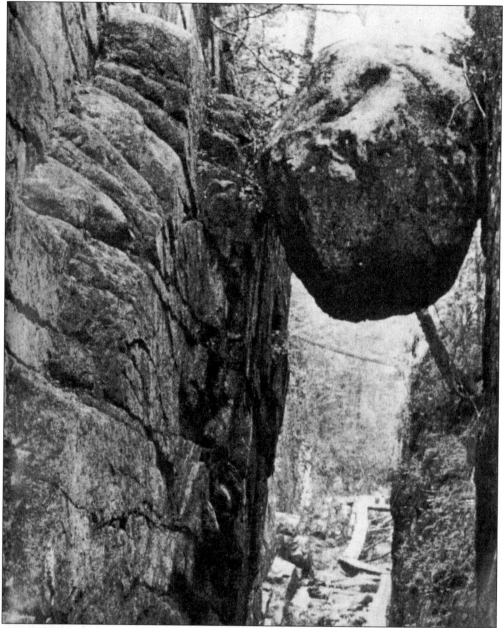

THE FLUME BEFORE THE BOULDER FELL, 1879. The Flume was first discovered in 1808 by Aunt Jess, the wife of Dave Guernsey, a farmer from Ireland. Aunt Jess, who was 93 at the time, accidentally found the gorge while she was looking for a lost cow. This massive boulder, lodged between the walls of the chasm, fell into the stream during a storm and flood in June 1883.

THE FLUME IN THE WINTER AFTER THE BOULDER FELL, 1930s. This chasm, over 700 feet in length and 11 to 24 feet in width, has 60- to 70-foot perpendicular walls rising on both sides.

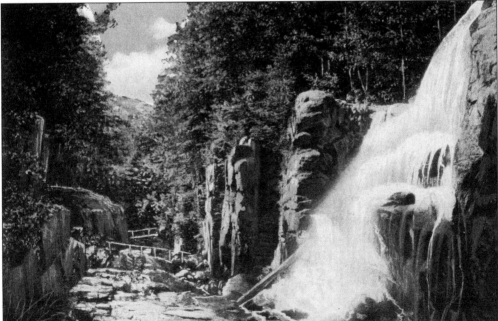

THE CASCADE IN THE FLUME, FRANCONIA NOTCH, 1930s. These cascades were formed by the erosion of a basalt dike over thousands of years. Today the Flume, the entrance to Franconia Notch, is visited by thousands of tourists each year.

27

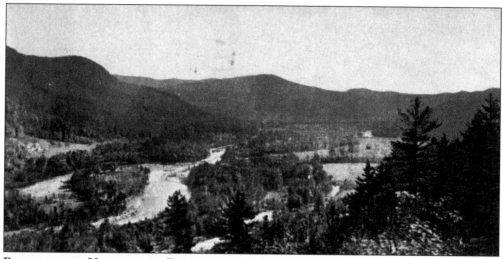

PEMIGEWASSET VALLEY FROM PARKER'S LEDGE IN NORTH WOODSTOCK. The Pemigewasset Valley is one of the most beautiful regions in the White Mountains. Its name, a compound of the Native-American words "Penaqui-wadchu-coash-auke," meaning "Crooked-Mountain-Pine-Place," is pronounced Pem-i-je-was-set, the accent falling on the fourth syllable. The river flows straight to the south from Profile Lake, descending more than 1,500 feet before it reaches Plymouth. About 25 miles below Plymouth, it unites with the outlet of Lake Winnipesaukee via the Winnipesaukee River at Franklin Falls; the result of this meeting of the waters is the Merrimack River.

SUGAR HILL FROM OVERLOOK NEAR THE KANCAMAGUS HIGHWAY. There is a bold ridge between Lisbon and Franconia, crossed by several roads. Its crest of pasture and woodland rises nearly 2,000 feet above the sea, and it affords a view of the White and Franconia Mountains en famille that is, in my opinion, one of the more beautiful prospects in New Hampshire.

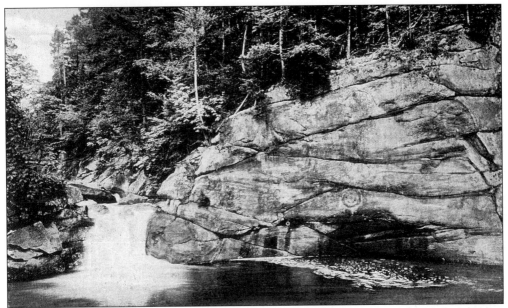

THE POOL, FRANCONIA NOTCH. A half mile east of the Flume House is a great pot-hole 50 feet deep. Ledges 100 feet high rise above it with alpine flowers and delicate ferns growing on the rocky terraces of the steep inaccessible cliffs.

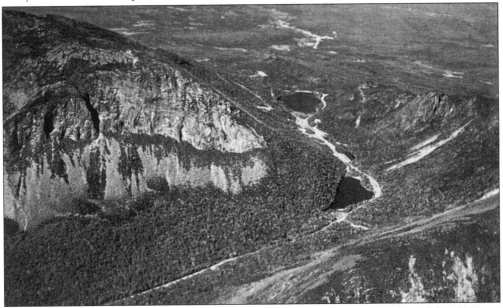

AN AERIAL VIEW OF FRANCONIA NOTCH. Among the many scenic wonders of this 600-acre reservation is the most perfect stone face in the world formed by nature, the first aerial passenger tramway on the North American continent, and the inspiring geological phenomenon of the Flume. Combined with the grandeur of the Franconia Mountains and the peaceful paradise of beautiful Echo Lake and Profile Lake is the unusual opportunity for campers, hikers, and picnickers to enjoy the many diversified recreation delights. This striking aerial view shows that portion of the massive granite ledges where the famous Old Man of the Mountain is located. Profile and Echo Lakes are also shown.

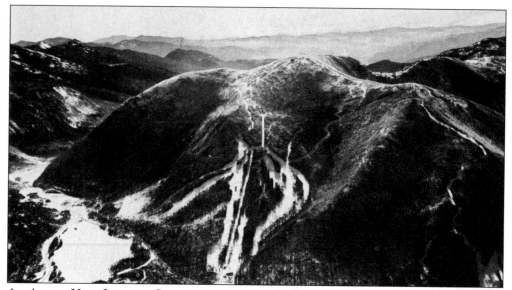

AN AERIAL VIEW LOOKING SOUTH OVER PROFILE (CANNON) MOUNTAIN (ALT. 4,100 FEET).
Franconia Notch is located to the left. The great swaths through the forest are ski trails.
Cannon Mountain is the long, massive ridge that enwells Franconia Notch on the west. It is
separated from Mt. Kinsman by a narrow and exceedingly rough valley. The whole mountain,
from which the Profile starts, is one of the noblest specimens of majestic rock that can be seen
in New Hampshire. While driving up from the lower part of the notch to the ski slopes of the
north, one may tire of the craggy contours sooner than of the sublime front and vigorous slopes
of Mt. Cannon itself, especially as it is seen, with its great patches of tawny color.

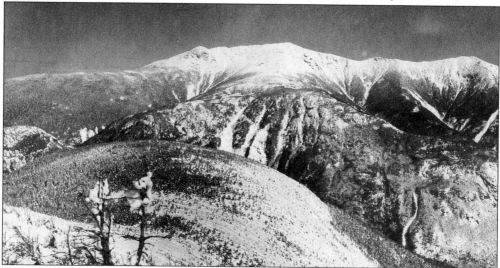

**MT. LAFAYETTE (ALT. 5,260 FEET) FROM CANNON MOUNTAIN (ALT. 4,100 FEET), MARCH
1960.** Across the notch, with its great spurs and the deep White-Cross Ravine, Mt. Lafayette is
seen in all its glory. One of the greatest wonders at the southern gateway is Franconia Notch, a
deep narrow canyon that has been eaten by a mountain brook in the coarse granite ledges near
the base of Mt. Flume. This mountain received its name at the time of the visit of the Marquis
de Lafayette to America, about the year 1825. It is one of the most symmetrical and attractive
of the New Hampshire peaks.

A VIEW FROM CANNON MOUNTAIN (ALT. 4,100 FEET) LOOKING SOUTH TOWARD NORTH WOODSTOCK. On the left, Mt. Liberty (4,459 feet) is visible with frost-covered spruce and fir in the foreground. Franconia Notch was reached on the south by the Pemigewasset Valley Railroad (open in 1883), which left the Boston & Maine Railroad at Plymouth and ran northward across Campton and other valley towns to a point in North Woodstock.

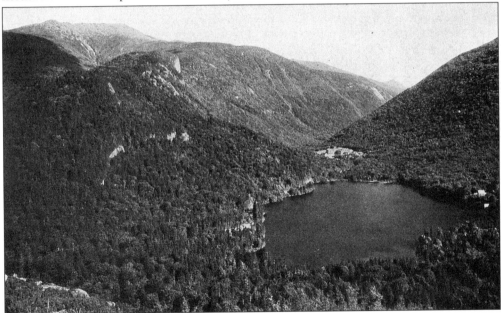

MT. LAFAYETTE (ALT. 5,260 FEET) FROM ARTIST'S BLUFF (ALT. 2,340 FEET). This mountain, located on the northern extremity of the range, is considered the greater of the Franconia Mountains. Although it resembles Mt. Washington in that it has massive spurs and deep ravines, it shows a marked difference in its shape and decision of line, and in the thin profile of its summit-ridge. The narrow crest-line slopes off sharply on either hand into dark gulfs below. Some believe the singular path that runs along its summit has been made by the passage of countless generations of animals.

31

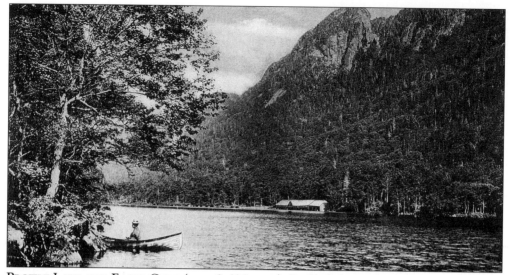

PROFILE LAKE AND EAGLE CLIFF (ALT. 3,420 FEET). Profile Lake is a beautiful mountain tarn located at the foot of Cannon Mountain and nearly surrounded by forests. It was formerly called Ferrin's Pond and then the Old Man's Washbowl. The pond above Profile Lake is the source of the Pemigewasset River, one of the chief contributors to the Merrimack River. Eagle Cliff is a great spur of Mt. Lafayette running to the west and northwest, partly separated from the mountain by a tangled ravine. The name was given by the Rev. Dr. Thomas Hill after he discovered an eagle's nest high up on the crags. The precipice has been scaled from near Echo Lake; the path up Lafayette ascends on the south side.

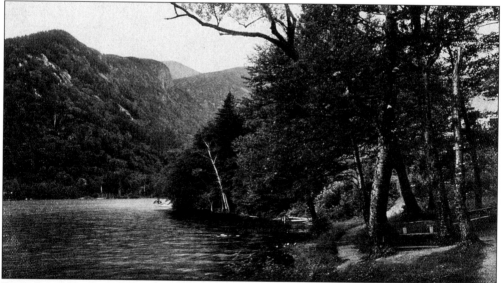

ECHO LAKE, EAGLE CLIFF, MT. LAFAYETTE. These are the iron-bound walls of Eagle Cliff (alt. 1,472 feet), a precipitous spur of Mt. Lafayette. Mt. Lafayette (alt. 5,260 feet), the most conspicuous of the Franconia Mountains, with a remarkably clear cut, sharp, thin crest-ridge, is nearly 1.5 miles long and is broken by several keen peaks of rock. Echo Lake, a bright, 28-acre, mountain lake 1,940 feet above sea level, lies under the purple ledges of Eagle Cliff that are mirrored in the smooth water. Echoes from bugle or voice leap from cliff to cliff far up the great cravices.

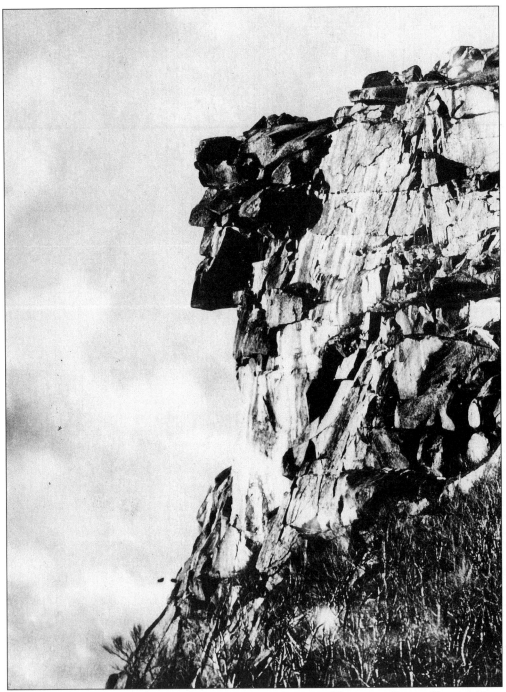

THE OLD MAN OF THE MOUNTAIN, THE MOST PERFECT NATURAL STONE FACE IN THE WORLD. Also called "The Profile," the "Great Stone Face" of Hawthorne's story is 40 feet high, and is located on the south end of Cannon Mountain, 1,400 feet above the ever beautiful Profile Lake. It is recorded that the Old Man of the Mountain was first seen in 1805 by Francis Whitcomb and Luke Brooks, two workmen who were working on the Notch Road. The profile itself consists of five ledges that give it the appearance of a human face.

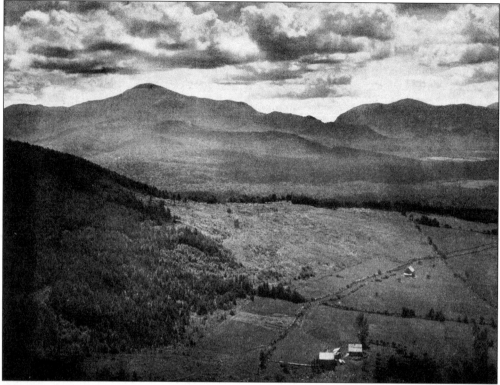

THE FRANCONIA MOUNTAINS FROM MT. AGASSIZ, BETHLEHEM. One cannot help but notice the depth of the foreground in this picture. We are located on the summit of Mt. Agassiz (alt. 2,379 feet) in Bethlehem looking out toward the peaks of the Franconia Range.

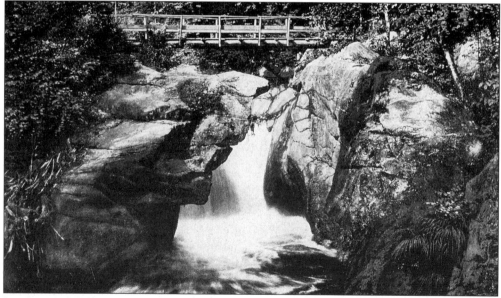

INDIAN LEAP ABOVE THE AGASSIZ BASIN. This deep, dark pot-hole is shadowed by high ledges so close together than one is tempted to leap across the chasm. The name is purely fictional, for no one has ever leaped over the stream.

MT. CANNON (ALT. 4,100 FEET) FROM FRANCONIA ROAD. The origin of the mountain's name is derived from the oblong rock near its summit that has the appearance of a cannon. Upon close examination one may notice that there are knobs on Kinsman Ridge, south of Cannon Mountain; they are called the cannon balls. The profile of the Old Man of the Mountain is located on the east ridge of this mountain.

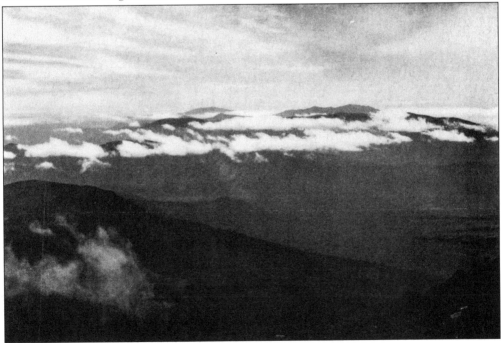

A CLOUD VIEW OF MT. LAFAYETTE (ALT. 5,260 FEET).

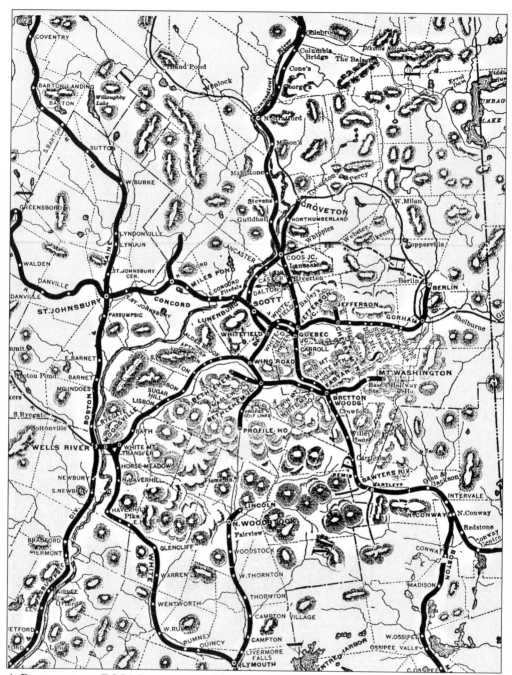

A Portion of a B&M System Map Dated May 1, 1907. The rail lines shown have been abandoned or are no longer in use.

Two

THE VALLEY OF
THE AMMONOOSUC

THE SUMMIT OF MT. AGASSIZ, (ALT. 2,369 FEET). This mountain, formerly known as Peaked Hill, affords a fine view over the White and Green Mountains. The present name of the mountain was given in honor of Professor Louis Agassiz, whose research of the glacial remains in this vicinity has proven to be of great value.

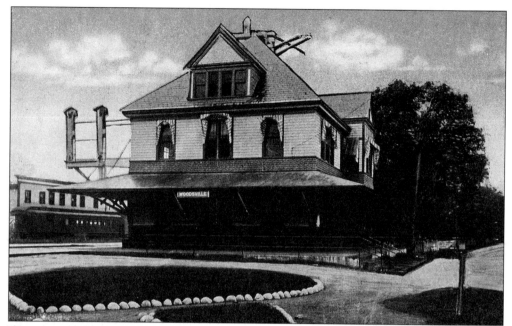

WOODSVILLE STATION, 1901. Originally, the village of Woodsville was a mere group of little houses, with a sawmill on the Ammonoosuc near the site of the present bridge. It remained comparatively unimportant until 1854, when the Boston, Concord & Montreal Railroad reached this point.

LITTLETON STATION, 1880. Stages regularly left this station for Franconia Village and Sugar Hill. Situated on the western edge of the White Mountains, Littleton is the headquarters of the northern section of the White Mountain National Forest, and is a springboard to the mountains themselves.

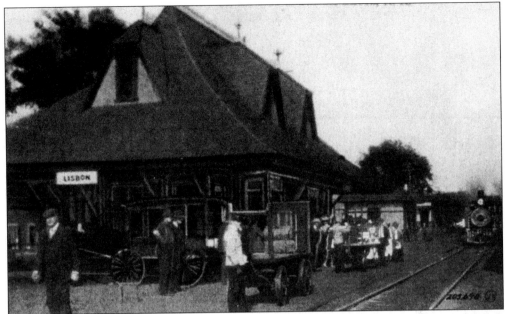

LISBON STATION, 1890. Stages once left this station for the Sunset Hill House and Hotel Look Off on Sugar Hill. Two miles above the Lisbon Station is the railroad station for Sugar Hill, but the lovely mountain village itself lies 5 miles up through the valley, a drive that encompasses beautiful views of the Presidential Range, the Franconia Mountains, and the quiet village of Franconia nestled in the valley. According to many summer visitors, the village of Sugar Hill was, and still is, regarded as the "finest resort of the Mountains."

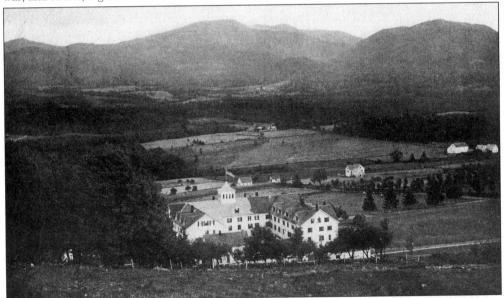

THE FRANCONIA MOUNTAINS FROM SUGAR HILL. Sugar Hill, so named because of the groves of sugar maples on its summit, offers a delightful view of the Franconia group, which can be seen from foundation to turret just beyond the deep trench of valley that lies between. This prospect is one of the grandest in the whole region, comprising as it does views of both the White and the Franconia Mountains.

MT. LAFAYETTE FROM SUGAR HILL. The view from Sugar Hill of Mt. Lafayette, towering above its neighbors, is superior to any in this group. On Lafayette's side is a deep ravine that, when filled with snow in the late spring or early fall, forms a cross similar to that of the Holy Mount of Colorado.

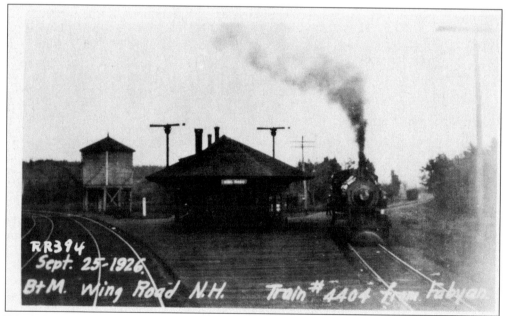

WING ROAD STATION, 1926. Located within the limits of the town of Bethlehem, this station offers a fine view of Mt. Lafayette and the Twin Mountains. The railroads of the White Mountains left the main line here, and continued up the Ammonoosuc Valley through the Mt. Washington Branch.

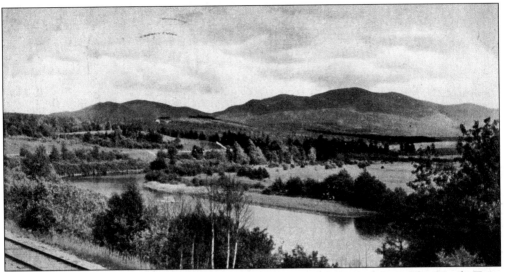

THE TWIN MOUNTAINS AND AMMONOOSUC RIVER NEAR BETHLEHEM. The North Twin Mountains (alt. 4,761 feet), Mt. Garfield (alt. 4,500 feet), and Mt. Lafayette (alt. 5,260 feet) lie in that order from east to west. Directly down the valley are Mt. Agassiz (alt. 2,369 feet) and Mt. Cleveland (alt. 2,424 feet), with lower hills on the right. Close by is the Lower Ammonoosuc Falls, which feature regular rock walls resembling fine masonry, glistening from the long action of the turbulent waters.

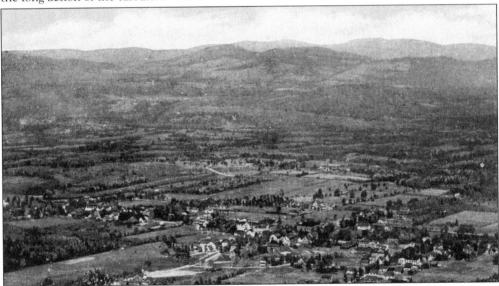

BETHLEHEM AND THE DALTON RANGE FROM MT. AGASSIZ (ALT. 2,369 FEET). Almost everyone visiting this delightful mountain town, high above the hay fever altitude, climbs Mt. Agassiz. Spread out before them is one of the finest panormas to be seen in this region. One of the chief views is the Dalton Range looming up in the distance. This range is a long and lofty wooded ridge, running across the town of Dalton from southwest to northeast. The hamlet of Dalton consists of but a few houses, and is situated on the Connecticut River at the head of the 15-mile falls, which is 8 miles from Lancaster and 6 miles from Whitefield. It is 1.5 miles from Dalton station on the Boston, Concord & Montreal Railroad, and less than .5 miles from the station of the Portland & Ordensburg Railroad, where that line crosses the Connecticut River.

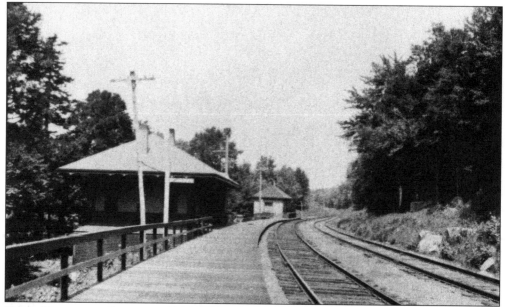

TWIN MOUNTAIN STATION, 1930. This town is one of the busiest little resorts in all the White Mountain area. Four miles north of the station rest the Twin Mountains (alt. 4,769 feet); to the south are the Franconia Peaks; and to the west are the Presidentials, with smaller peaks on all sides.

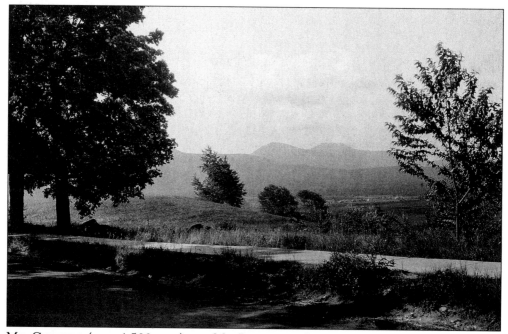

MT. GARFIELD (ALT. 4,500 FEET) AND MT. LAFAYETTE (ALT. 5,260 FEET) FROM THE GRAND VIEW HOTEL, TWIN MOUNTAINS.

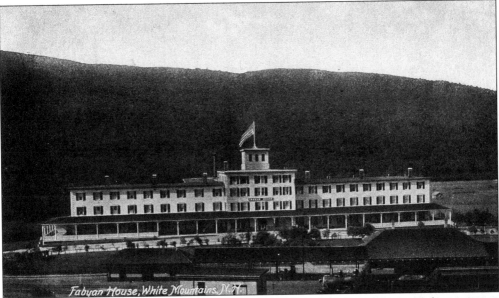

FABYAN'S STATION, 1908. This station, the most important railroad point in the mountain region, is 208 miles from Boston. All Boston and New York express trains ran to and from this station, as did the Mt. Washington trains, for the Crawford House and through the Crawford Notch. The Fabyan House was situated opposite the station.

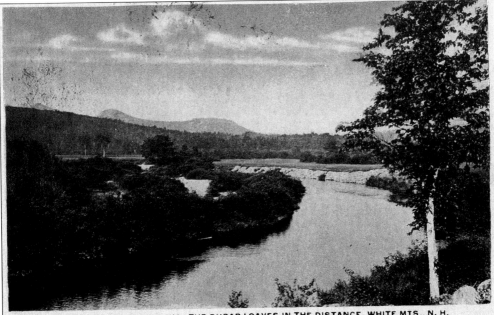

THE AMMONOOSUC RIVER FROM FABYAN'S. The Sugar Loaves (alt. 2,609 feet) are shown here, with the Benton Range in the distance. This Ammonoosuc flows off Mt. Washington through the Ammonoosuc Ravine and merges with the Connecticut River in Woodsville, NH. The river falls nearly 6,000 feet from its origin at the Lakes of the Clouds just below the summit of Mt. Washington. The name "Ammonoosuc" is an Abenaki word meaning "Fish Place" ("namos" means "fish" and "aukee" means "place").

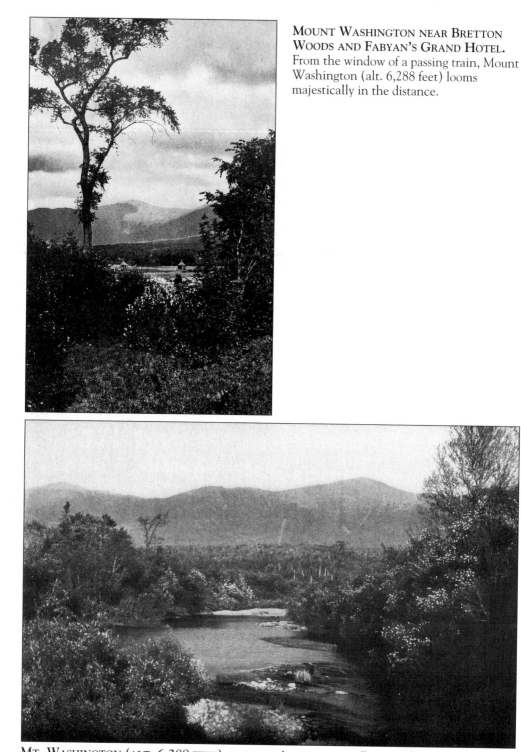

MOUNT WASHINGTON NEAR BRETTON WOODS AND FABYAN'S GRAND HOTEL. From the window of a passing train, Mount Washington (alt. 6,288 feet) looms majestically in the distance.

MT. WASHINGTON (ALT. 6,288 FEET) AND THE AMMONOOSUC RIVER. The trains on the Mt. Washington Branch of the BC&M Railroad from Littleton, Bethlehem, and the Fabyan House made connections with the Mountain Railway near Ammonoosuc.

44

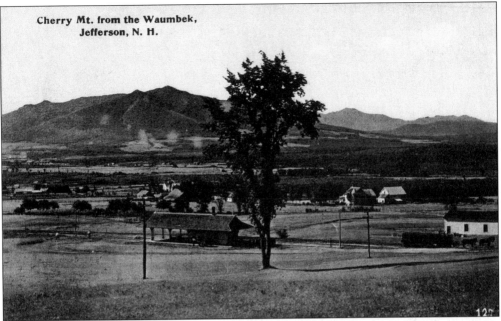

Cherry Mt. from the Waumbek,
Jefferson, N. H.

CHERRY MOUNTAIN (ALT. 3,573 FEET) FROM THE WAUMBEK STATION, JEFFERSON, 1891.
According to the state historic marker, which is dated July 10, 1885, the Cherry Mountain
Slide contained an estimated one million tons of trees, mud, and boulders. Dan Walker, a
workman at Oscar Stanley's farm, died from injuries that he received from the slide. The home,
barn, and cattle were all lost.

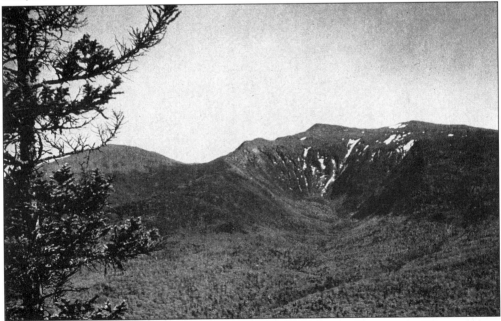

KING'S RAVINE FROM LOOKOUT LEDGE (ALT. 2,260 FEET), THE SOUTHEAST RIDGE OF MT.
RANDOLPH (ALT. 3,081 FEET). Cut deep into the side of Mt. Adams, this ravine is a wild
profusion of boulders with streams cascading down to form, in many places, natural caves where
the frigid water coats the surroundings with ice.

45

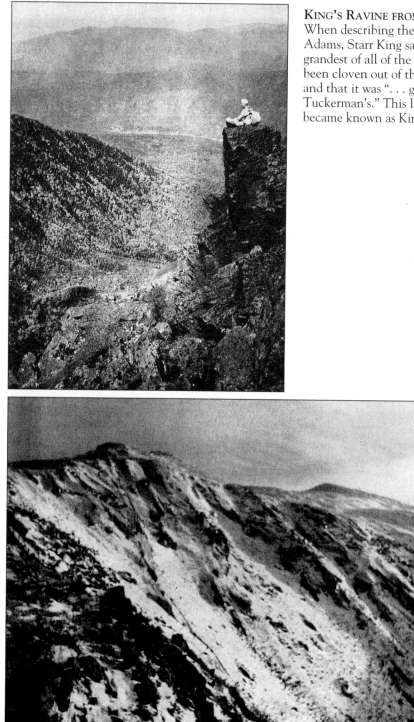

KING'S RAVINE FROM MT. ADAMS. When describing the ravine of Mt. Adams, Starr King said it was ". . . the grandest of all of the gorges that have been cloven out of the White Hills," and that it was ". . . grander than Tuckerman's." This landscape later became known as King's Ravine.

THE HEADWALL OF KING'S RAVINE, QUINCY ADAMS (ALT. 5,410 FEET) AND ADAMS (ALT. 5,799 FEET). This is a superb view into the ravine, named in honor of Starr King, who first explored its depth in 1857.

WHITEFIELD STATION, 1940. This was a town on the main line, 125 miles from Concord and 200 from Boston. The Whitefield & Jefferson Railroad ran hence to Jefferson.

CHERRY MOUNTAIN FROM WHITEFIELD (ALT. 3,573 FEET). The northern side of the White Mountains, reached by the Whitefield & Jefferson Railroad, has a beauty and grandeur not conceived of by the visitor unfamiliar with that area. This mountain is a long massive ridge that runs nearly north for several miles in the town of Carroll. Most of its area is covered with dense wooded forest, giving it a peculiar dark appearance when seen from a distance. The ridge was formerly known as Pondicherry Mountain. The highest part is 3,670 feet above sea level; on the north end of the ridge is the sharp peak of Owl's Head, which is conspicuous in the view from east to west.

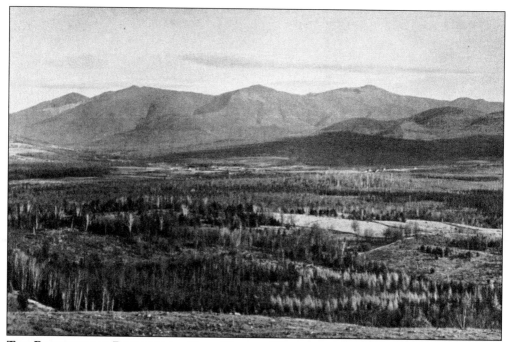

THE PRESIDENTIAL RANGE FROM BRAY HILL IN WHITEFIELD. A choice eminence of several lakes and ponds may be seen in the valley below—to the west are Burns Pond and Forest Lake; to the east are Cherry Pond and the series of ponds along John's River; and to the north are Mirror Lake and Blood Pond.

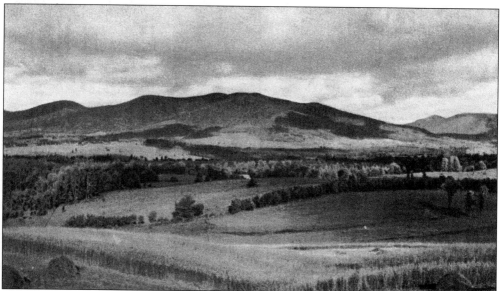

MT. STARR KING (ALT. 3,907 FEET) FROM WHITEFIELD. This mountain is properly a portion of the Pilot Range, of which it forms the most southern point. The flanks of the mountain meet the plain of Israel's River at the village of Jefferson Hill. The mountain is composed of feldspathic rock, and covered entirely with woods up to the summit. In 1861, the name of the peak, Starr King, was bestowed in honor of the author of *The White Hills*, who extols the scenery of this vicinity with so much eloquence.

Three

THE PRESIDENTIAL RANGE

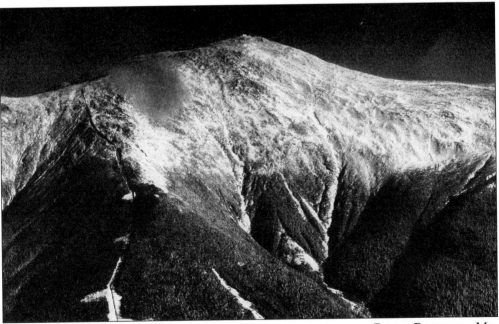

AN AERIAL VIEW OF THE AMMONOOSUC RAVINE AND THE RACK RAILWAY, MT. WASHINGTON. I saw the whole noble company of mountains, from highest to lowest; the deep depressions through which the Connecticut, Merrimack, the Saco, and the Androscoggin Rivers wind toward the lowlands. I saw the lakes that nurse the tributaries of those waterways, and the great northern forests, the notched wall of the Green Mountains, the wide expanse of level land like the ocean, and finally the ocean itself. The utmost I can say of this panorama is that it is a gift from God.

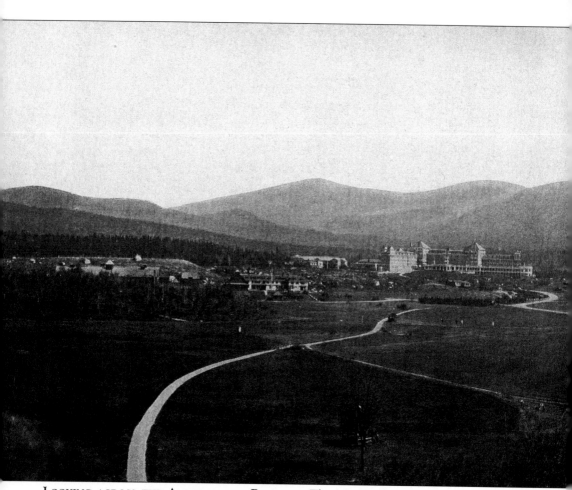

LOOKING ACROSS THE AMMONOOSUC PLATEAU. The Mt. Washington Hotel is shown here with the majestic Presidential Range in the background. The panorama includes the complete sweep of the Presidential Range. Mt. Washington, 6,288 feet above sea level, occupies the center. Grouped about are Mt. Adams (alt. 5,799 feet), Mt. Jefferson (alt. 5,716 feet), Mt. Clay (alt. 5,533 feet), and Mt. Madison (alt. 5,366 feet), together with Mts. Monroe (alt. 5,372 feet) and Webster (alt. 3,910 feet). Situated in the midst of this natural amphitheater at an altitude

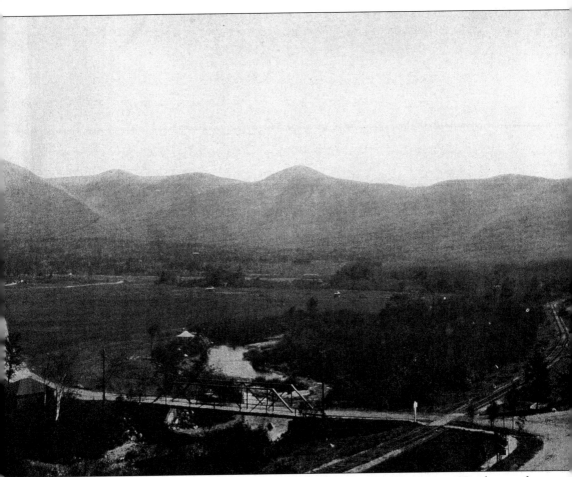

of 1,600 feet on a spur of Mt. Deception (alt. 3,671 feet) is the Mt. Washington Hotel, one of the largest and most elegant, grand resort hotels in America. The Presidential Range, sometimes referred to as the "Ridgepole of New England," is on the watershed between the Connecticut and Merrimack Rivers. Named in honor of the statesmen of the early Republic, the mountains stand in silent repose and grandeur. Huge in bulk, wild, and high, this range is one of the most beautiful in the United States.

MT. WASHINGTON FROM THE GIANT'S GRAVE. Ethan Allen Crawford's house stood at the base of this glacial mount, which was removed in 1870. It is written that the Giant's Grave was a mound of river gravel, or a sandbar formed by the action of ocean waves against the adjacent hills. It was 300 feet long, 75 feet wide, and 50 feet high. At one time a cannon was kept upon its summit to arouse echoes in the mountains. The image, drawn by I. Sprague, appears in Oakes' *White Mountain Scenery* (1848).

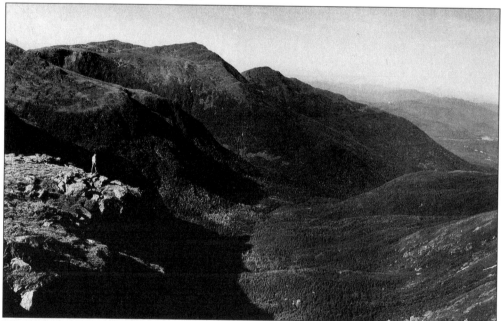

THE GREAT GULF OF MT. WASHINGTON (ALSO CALLED THE GULF OF MEXICO), AUGUST 1945. This photograph was taken from a point near Westside Trail up Mt. Washington looking across the Great Gulf Wilderness to Mt. Adams (alt. 5,798 feet) and Mt. Madison (alt. 5,363 feet). The North Knee of Mt. Jefferson (alt. 5,716 feet) is in the center foreground. The forest that fills the bottom is so dense as to prevent the adjacent peaks from being seen. During stormy weather vast masses of mist roll into and move about the gulf, until it seems like an immense cauldron. The best view for seeing the gulf is at the gap between Mt. Washington and Mt. Clay. The Great Gulf is the largest cirque in the White Mountains.

ON THE HEADWALL OF THE GREAT GULF.
The headwall, bounded on the south by the slopes of Mt. Washington and on the west by the summit ridge of Mt. Clay (alt. 5,533 feet), rises about 1,100 to 1,600 feet above a bowl-shaped valley enclosed by steep walls that extend east for about 3.5 miles. This gulf is the profound gorge between Mt. Washington and Mts. Jefferson, Adams, and Madison, in which rises the West Branch of the Peabody River. The glacial action that formed the gulf and its tributary gulfs is believed to have occurred prior to the most recent ice age. The first recorded observation of the Great Gulf was by Darby Field in 1642, and the name probably had its origin in 1823 from a casual statement made by Ethan Allen Crawford, who lost his way one cloudy day and came to "the edge of a great gulf."

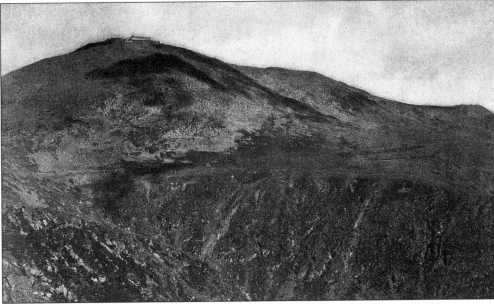

TUCKERMAN'S RAVINE AND MT. WASHINGTON. This massive gorge, located on the east side of Mt. Washington, north of Boott's Spur, is divided into two sections—the broad vestibule (which contains the cascades and Hermit Lake) and the inner and higher chasm of the ravine itself. It is considered the most remarkable piece of scenery of this character in all New England, for though it is neither so deep nor so long as King's Ravine, it surpasses it in the steepness and sweep of its cliffs, and in its close relation to the supreme summit, Mt. Washington.

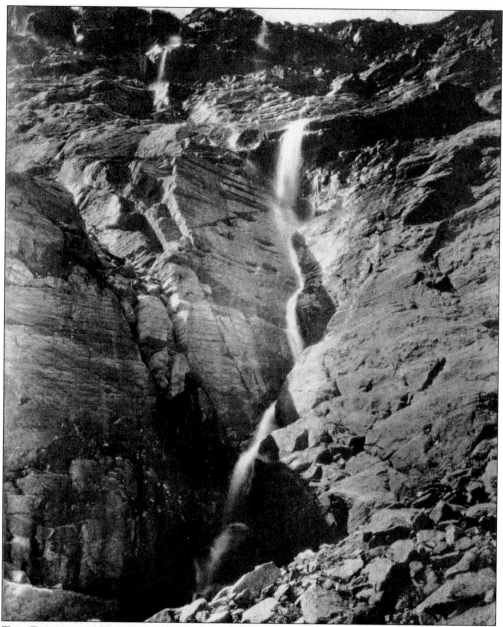

THE FALLS OF A THOUSAND STREAMS, TUCKERMAN'S RAVINE, AND MT. WASHINGTON.
Here the snow may last until the third week of August. It is possible that the glistening of these rivulets in the sunlight may have given rise to the early tradition of a great carbuncle.

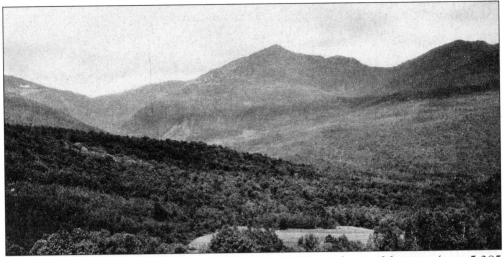

MTS. JEFFERSON (ALT. 5,716 FEET), ADAMS (ALT. 5,799 FEET), AND MADISON (ALT. 5,385 FEET) FROM THE GLEN. The dull gray of Jefferson is relieved by many blocks of white quartz, and on the south is the long grassy slope of the Monticello Lawn, an allusion to President Jefferson's home in Virginia. Mt. Adams is the second highest of the New England mountains; however, it is exceeded by no other in picturesque grandeur and bold alpine character. As seen from most points, it presents the appearance of a symmetrical pyramid, rising from a high and narrow ridge and flanked by bold crags. Starr King bestowed upon the epithets of Mt. Madison the "Apollo of the highlands," calling it the "beautiful, clear, proud, charming, gigantic," and "of feminine symmetry."

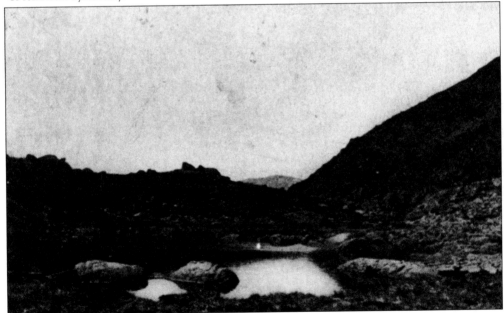

STARR LAKE NEAR THE SUMMIT OF MT. MADISON, NOVEMBER 1906. The elevation of the .5-acre lake is 4,896 feet above sea level. The upper portion of the mountain is above the timberline; the area below the timberline is known to naturalists as the alpine region. The mountain is covered with ragged fragments of weather-beaten rocks, among which are nestled rare flowers.

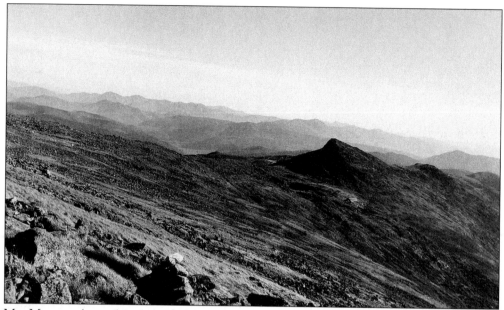

MT. MONROE (ALT. 5,385 FEET), OCTOBER 1954. The Lakes of the Clouds and the AMC hut can be seen in this panorama of the White Mountains taken from the Westside trail of Mt. Washington. Due to its shape and massive crags, Monroe presents a fine alpine appearance to the distant observer.

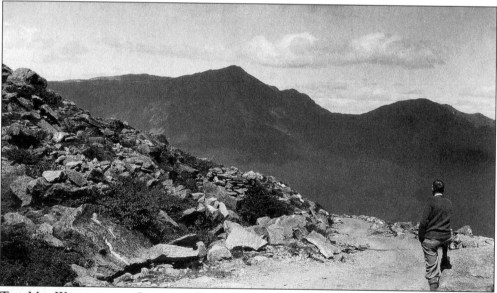

THE MT. WASHINGTON CARRIAGE ROAD LOOKING INTO THE GREAT GULF WILDERNESS, 1934. Mt. Adams, Mt. Quincy Adams, and Mt. Madison are in the background in this view of the world's first mountain toll road. The road opened for business on August 8, 1861. A long stream of Concord Coaches reached the summit after a ceremonial 8-mile drive up from the Glen House. In past years it has been the scene of many unusual races and endurance tests. P.T. Barnum called the view from the top of the mountain "the second greatest show on earth." Native Americans thought the Great Spirit lived on the summit of the highest peak in the Northeast.

THE MT. WASHINGTON CARRIAGE ROAD ABOVE THE TIMBER LINE. For the first few miles, the road climbs through scenic woods. The half-way point (4 miles, 3,840 feet above sea level) is almost exactly at timberline; from there on, the views are spectacular.

MT. ADAMS (ALT. 5,799 FEET) AND MT. MADISON (ALT. 5,366 FEET) FROM "THE HORN." Here is a prominent shoulder of the mountain, once known as "the Ledge," now referred to as "The Horn." Further up, the road skirts the edge of the Great Gulf and crosses the Cow Pasture, where once was kept the herd that supplied fresh milk to the Summit House. The road then climbs to a parking lot just below the summit.

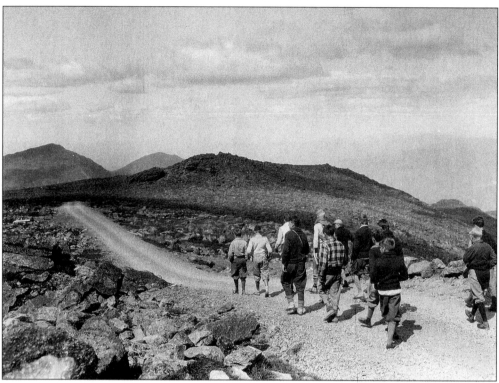

MEMBERS OF A BOYS' CAMP HIKING UP THE SUMMIT OF MT. WASHINGTON ALONG THE CARRIAGE (AUTO) ROAD.

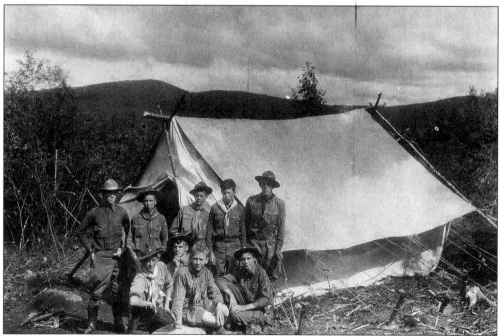

BOY SCOUTS, 1931. District Ranger Truman E. Hale (back row, left) and his crew of Boy Scouts improve the Valley Way Trail over the Presidential Range.

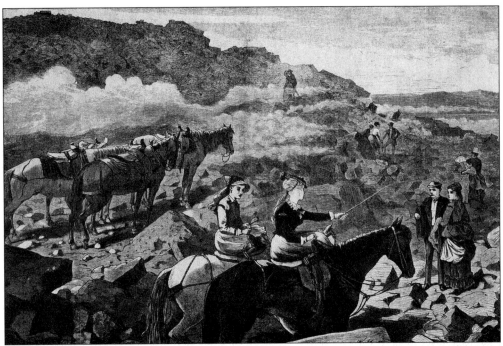

AN EQUESTRIAN GROUP ON MT. WASHINGTON, JULY 1869, IN A MAGAZINE ILLUSTRATION BY WINSLOW HOMER. In its earlier days, people went up and down the Carriage Road on horseback and snowshoes, as well as in automobiles.

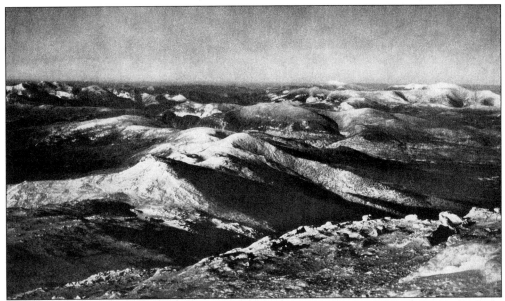

A SCENIC VIEW FROM MT. WASHINGTON. This view, looking toward the southwest, includes 40 or more peaks, from Mt. Carrigain (alt. 4,700 feet) at the left to Mt. Hale (alt. 4,054 feet) at the very right edge of the picture. Mt. Moosilauke (alt. 4,802 feet) stands out plainly just to the right of the center, with Mt. Liberty (alt. 4,459 feet) in front of it. The Lakes of the Cloud's AMC hut can be seen in the foreground.

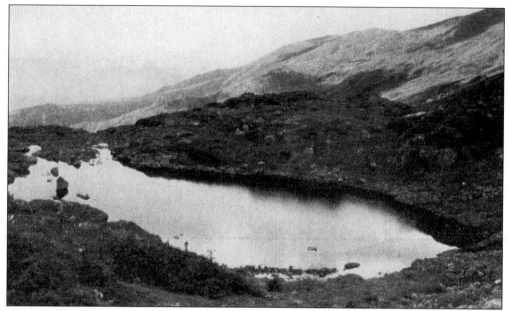

THE LAKE OF THE CLOUDS. This small alpine tarn serves as the source of the Ammonoosuc River. It is located a short distance from the summit of Mt. Washington, in a small bowl on the northwest side of the ridge near the low point between Mt. Washington and Mt. Monroe. There are two of these lakes—the larger of them, often called the Lower Lake, is at an elevation of 5,025 feet with an area of 1.2 acres, while the much-smaller Upper Lake has an elevation of 5,050 feet, with an area of .4 acres.

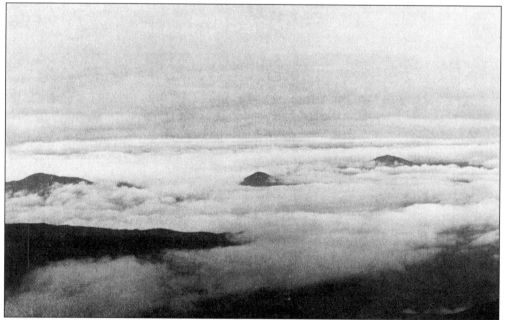

ABOVE THE CLOUDS, THE SUMMIT OF MT. WASHINGTON. There is no finer mountain effect than that produced by the heavy masses of vapors, not unlike the ocean's billows, as they gather in the valley. "Below us, seethed with mists, a sullen deep; From thawless ice-caves of a vast ravine Roll sheeted clouds across the land unseen." —Lucy Larcom

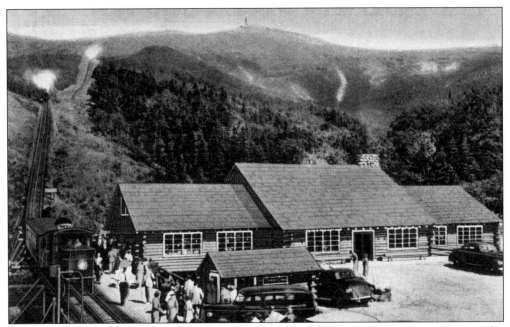

THE NEW MARSHFIELD HOUSE AND THE MT. WASHINGTON COG RAILWAY, 1950S. The Marshfield House is located at the base station of the Cog Railway. It is from here that the curious little inclined trains start on their way to the summit of Mt. Washington. Sylvester Marsh of Littleton, NH, first had the idea to build a mountain-climbing railroad. In 1858 he exhibited a model of his engine and Cog Railway to the New Hampshire State Legislature; he was granted a charter to build a steam railway up Mt. Washington and Lafayette, although few thought it would work. His first job was to build a turnpike to the location now known as the base station, some distance below where passengers now take the train. (The terminal is now at Marshfield—a coined place name commemorating Marsh and Darby Field.)

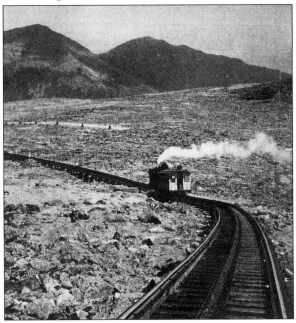

A COG RAILWAY TRAIN ON MT. WASHINGTON. The invention of the Cog Railway itself came from Herrick Aiken of Franklin, NH, but it was Marsh who pushed the project through to completion. During the summer of 1866, a quarter mile of track was built including a trestle bridge crossing the Ammonoosuc River. On August 29, 1866, the first practical demonstration of the Cog Railway was held, the engine taking its load of 40 passengers up a grade of 15 degrees quite easily.

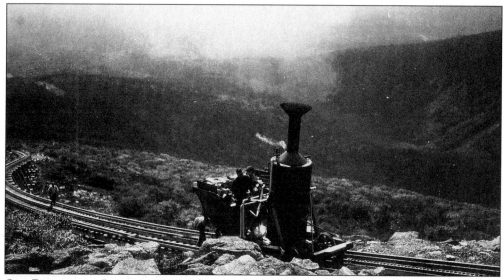

OLD PEPPERSASS, JULY 20, 1929. This was the first engine ever built on the Cog Railway. It was so named because of its fancied resemblance to a pepper sauce bottle. On July 20, 1929, there was a gala festival, including a final run up the mountain. Something went wrong, however, and just above Jacob's Ladder, the old engine went down the mountain, around a curve at a terrific speed, and onto the rocks below. Since that time, there have been no more experiments with relics of the past.

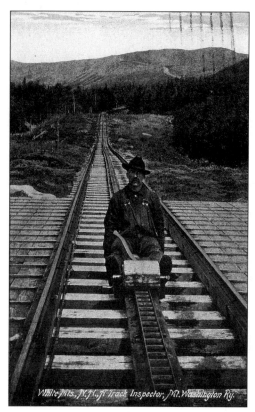

A TRACK INSPECTOR ON THE COG RAILWAY, JANUARY 1929. The essential feature of the Cog Railway is the driving mechanism. On the track, in addition to the outside rails, there is a central cog rail consisting of two pieces of wrought-angle iron, placed parallel and connected by iron pins 4 inches apart. Teeth on the driving wheel of the engine mesh with the cog rail and draw the whole train up the mountain. I understand that this mechanism has been copied for mountain railroads elsewhere in the world, including one on Mt. Rigi in Switzerland.

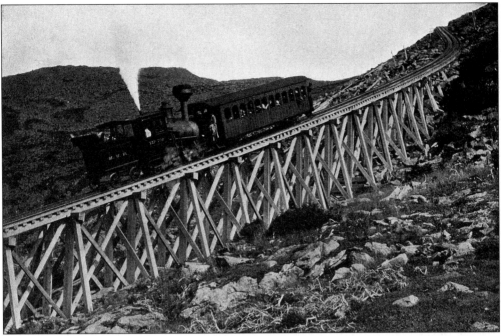

JACOB'S LADDER, MT. WASHINGTON RAILWAY. This massive trestle, over which the cog-wheel engine pushes the coach up the steep side of Mt. Washington (a distance of 3 miles), has an average grade of 1,300 feet and a maximum grade of 1,980 feet to the mile. At this point the tree line ends and the sub-alpine vegetation begins. No doubt one of the greatest impressions of the ride from the base station to the summit of Mt. Washington is the crossing of Jacob's Ladder, and that pause for a view beside the depths of the "Great Gulf."

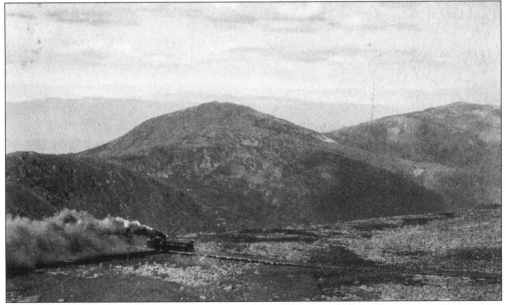

THE COG RAILWAY NEAR THE SUMMIT OF MT. WASHINGTON. Mts. Clay, Jefferson, and Adams can be seen here, with the Great Gulf in the foreground. From Fabyan and Bretton Woods a spur of the Boston & Maine ran directly to the base of Mt. Washington.

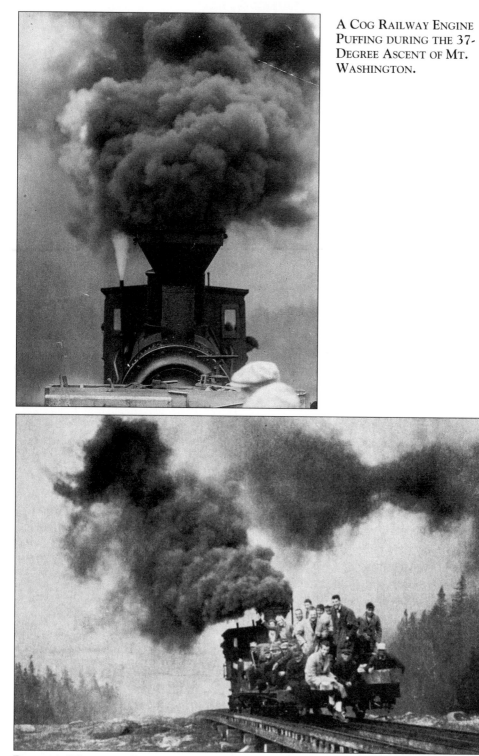

A COG RAILWAY ENGINE PUFFING DURING THE 37-DEGREE ASCENT OF MT. WASHINGTON.

BRIGHT'S "BELCHING DEVIL" TRANSPORTING SKIERS TO THE SUMMIT OF MT. WASHINGTON ON AUGUST 21, 1915.

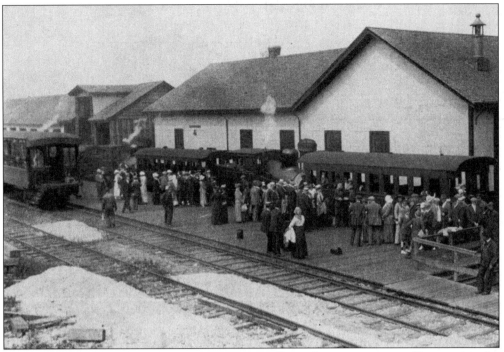

MEMBERS OF THE AMC TAKING TRAINS AT THE BASE STATION FOR THE DEDICATION OF THE NEW SUMMIT HOUSE, AUGUST 21, 1915.

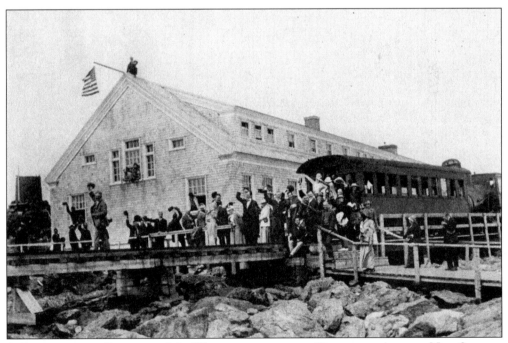

A PARTY ON THE SUMMIT OF MT. WASHINGTON AT THE DEDICATION OF THE NEW SUMMIT HOUSE, AUGUST 21, 1915.

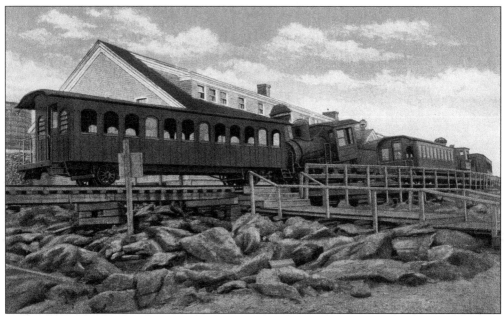

THE SUMMIT HOUSE, 1900. Patiently, a Cog Railway train waits for its passengers for their trip down Mt. Washington.

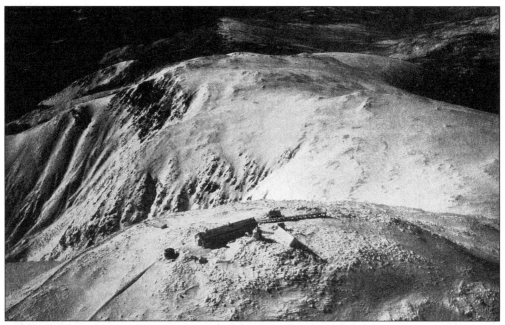

THE SUMMIT OF MT. WASHINGTON (ALT. 6,288 FEET), WITH TUCKERMAN RAVINE AND BOOTT SPUR IN THE CENTER BACKGROUND. From this vantage point high above New England, we may gaze east as far as the Atlantic Ocean at Portland, ME, and west as far as Lake Champlain. To the south is the shimmering surface of Lake Winnipesaukee, and to the north is the misty outline of Lake Memphremagog.

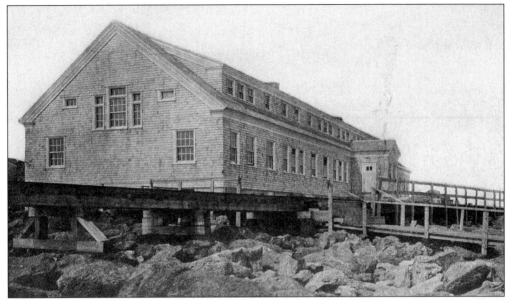

THE SUMMIT HOUSE ON MT. WASHINGTON. In 1632, Darby Field first gained the summit, guided by two Native Americans from Portsmouth. In 1784 seven gentlemen reached the summit and gave the mountain its name. The first shelter for travelers on the summit was built of stone by Crawford in 1821. The original Summit House, built in 1852, was demolished in 1884 to make room for a modern Summit House. In 1908 the second house was destroyed by fire; it was replaced in 1915 by a new two-story Summit House, which featured an entrance directly from the Mt. Washington Cog Railway Station platform, an office, a dining room accommodating 80 guests, a lounging room with a spacious fireplace, a waiting room, and a souvenir stand all on the first floor, with 18 rooms, lavatories, and bathrooms on the second floor.

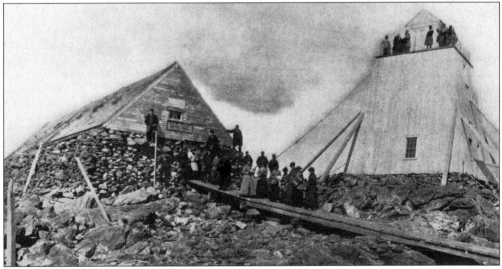

THE TIP TOP HOUSE AND OBSERVATORY. The first serious attempts to place an observatory of any kind on Mt. Washington were made in 1852 and in 1859, but nothing came of either project. This house was built in 1853 of natural stone from the mountain top. It was the only hotel until the erection of a newer Summit House in 1884.

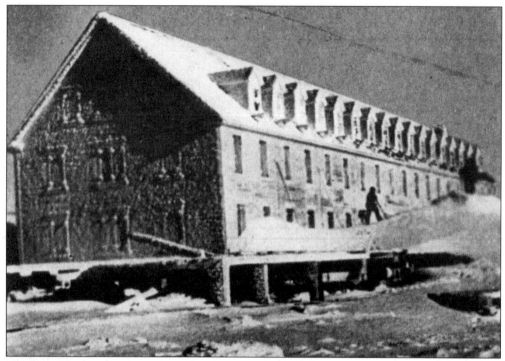

THE SUMMIT HOUSE IN WINTER, C. 1875. In 1869, C.H. Hitchcock, a professor of geology at Dartmouth College, and his assistant, J.H. Huntington (for whom Huntington Ravine is named), were granted permission to adapt the engine house of the Cog Railway for use as an observatory.

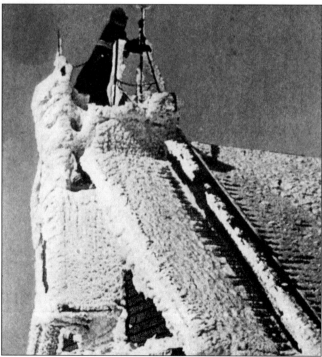

AN OBSERVER ON THE SUMMIT OF MT. WASHINGTON, C. 1875. On November 13, 1870, a five-man crew, including an observer and telegrapher for the U.S. Signal Service (which, at the time, made weather observations), began regular observations. The program continued until 1887, and then in the summer only until 1892. From 1874 on, the observers were housed in the so-called Signal Station, which remained on the summit until the great fire of 1908.

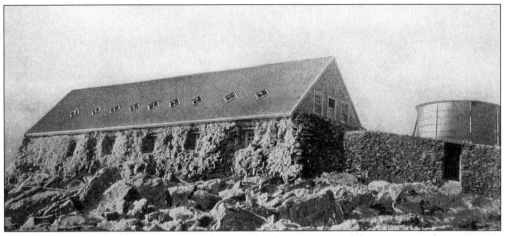

THE TIP TOP HOUSE. From 1884 until 1908, this house was used for a variety of purposes. In 1908, after surviving the conflagration that destroyed all other buildings at the summit, it again became the only available accommodation for guests, and it served as such until 1915, when the Summit House Restaurant was completed. The Tip Top House was destroyed by fire in 1915, but was restored in 1916 with the addition of a covered stone passageway connecting it to the Summit House.

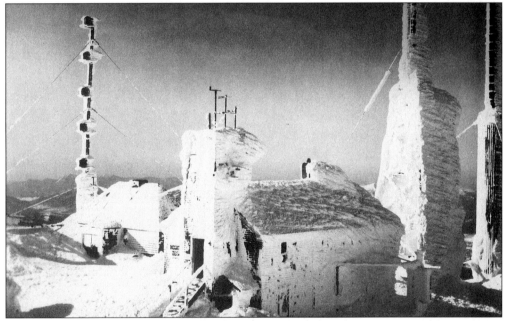

THE OBSERVATORY AND ITS SEPARATE INSTRUMENT TOWER IN THE WINTER OF 1937–38. The present observatory was launched in 1932 with a grant from the New Hampshire Academy of Science. That very year was the first year scientists around the world pooled their meteorological observations to help develop new theories about the weather. The lowest temperature ever recorded on the summit is -46 degrees F. The highest wind velocity ever recorded was set at 231 mph during a gust measured on April 12, 1934. The Mt. Washington Observatory is a Class-A Weather Station of the U.S. Weather Bureau and, in addition, conducts a number of scientific programs all generally relating to the physics of the upper atmosphere. The observatory is a non-profit corporation; new members are cordially welcome.

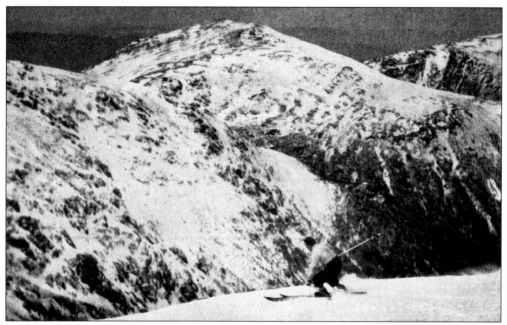

ALPINE SKIING ON THE NORTH SIDE OF MT. WASHINGTON. Mt. Clay (alt. 5,533 feet, on the left) and Mt. Jefferson (alt. 5,716 feet) are visible in the background.

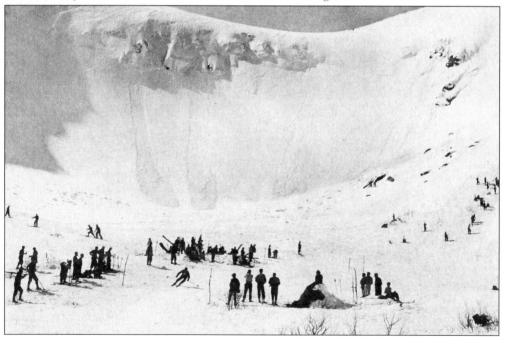

TUCKERMAN RAVINE, APRIL 1937. This huge crescent, cut out of the mountain, may well be called a mountain colosseum. It is named in honor of Dr. Edward Tuckerman, professor of Botany at Amherst College, who, in 1837, collected specimens of the vegetation of the White Mountains. One of his greatest contributions was to characterize the vegetation of the Presidential Range. Tuckerman is also credited with having named Oakes Gulf after that botanist.

TUCKERMAN RAVINE WITH BIG HEADWALL, LITTLE HEADWALL, AND THE JOHN SHERBURNE TRAIL IN THE FOREGROUND. This oft-mentioned ravine, famous for its snow arch (which has been known to remain as late as August), is hollowed from a spur of Mt. Washington upon its eastern side, and can be reached by a descent from the Summit House, a distance of a 1.25 miles. Into this enormous center the snows of winter sweep, to a depth of a hundred feet or more. A cascade tunnels beneath it, and thus it wears away, forming a roofed arch that eventually collapses. One measurement of this snow arch had it at 294 feet long, 84 feet broad, and 40 feet high.

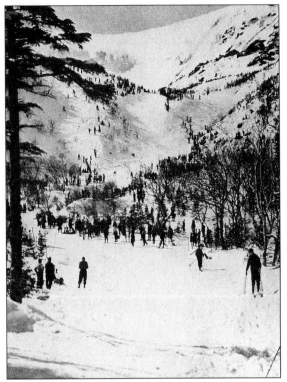

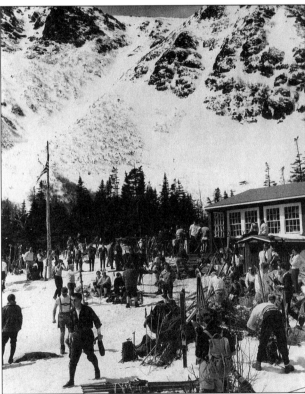

SPRING SKIERS AT THE TUCKERMAN RAVINE SHELTER, APRIL 22, 1962. The snow may remain in the head of the ravine until the latter part of the summer months, but it disappears before the autumnal storms set in. It should be noted that skiing areas in the ravine, and also those in the Great Gulf, or on any part of the mountain above the timberline, are subject to wide temperature variations within short periods of time. The skiing season on the Tuckerman Headwall starts about the middle of March and may last into June. The ravine area and the John Sherburne Ski Trail are patrolled by Forest Service rangers and the Mt. Washington Volunteer Ski Patrol.

71

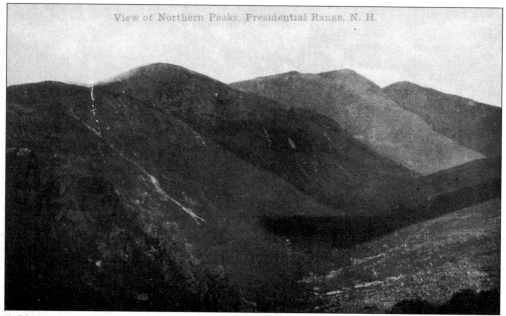

View of Northern Peaks, Presidential Range, N. H.

A VIEW OF THE NORTHERN PEAKS OF THE PRESIDENTIAL RANGE, 1911, TAKEN FROM MT. WASHINGTON. From left to right are Mt. Clay (alt. 5,533 feet), Mt. Jefferson (alt. 5,716 feet), Mt. Adams (alt. 5,799 feet), and Mt. Madison (alt. 5,366 feet).

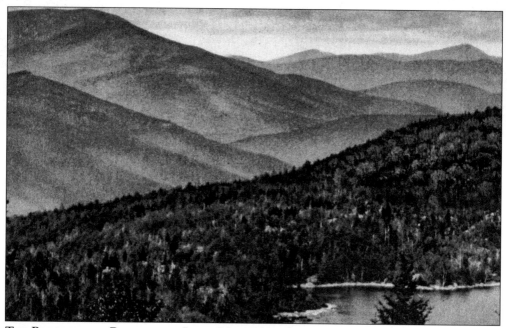

THE PRESIDENTIAL RANGE FROM LOON MOUNTAIN, LINCOLN, NH.

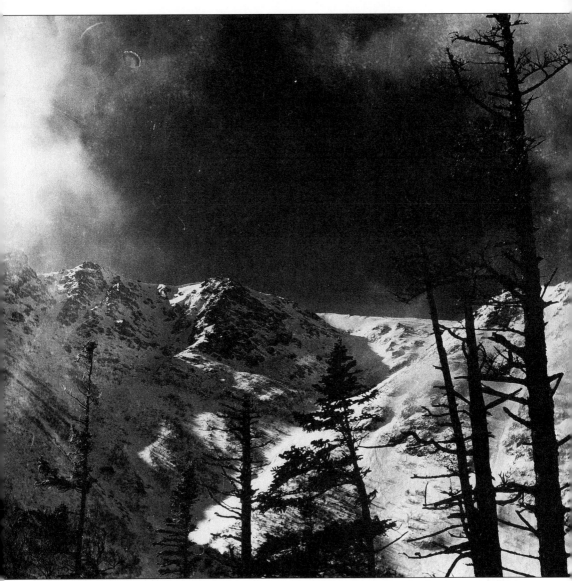

A VIEW LOOKING TOWARD BOOTT SPUR. This great ridge, nearly 3 miles long, runs southeast from Mt. Washington between Tuckerman's Ravine and Oakes Gulf. It is about 5,500 feet high, and has several masses of rugged rocks drawn across its line. The nearly level expanse between the base of the cone and the crags on the plateau was formerly called Carrigain's Lawn, but later became known as Bigelow's Lawn in honor of Dr. Jacob Bigelow, an early explorer in this region. It is the largest of the Presidential lawns. Both the Montalban Ridge and the Rocky Branch Ridge descend from Boott Spur and quickly drop below the treeline, continuing south in thick woods with some occasional open summits.

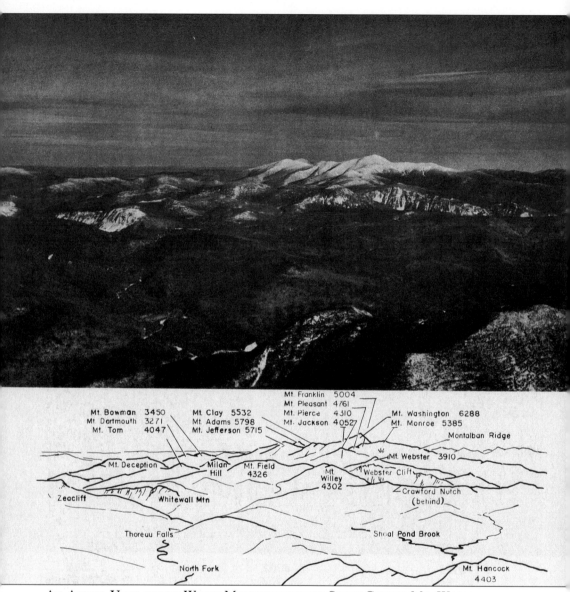

AN AERIAL VIEW OF THE WHITE MOUNTAINS WITH SNOW-CAPPED MT. WASHINGTON AND THE PRESIDENTIAL RANGE IN THE CENTER BACKGROUND. The observers were housed in the so-called Signal Station, which remained on the summit until the great fire of 1908.

74

Four

THE SACO VALLEY

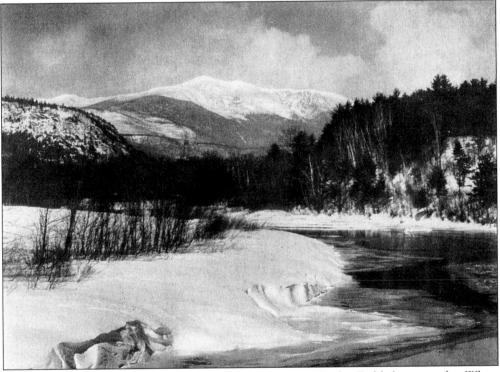

MT. WASHINGTON AND THE SACO RIVER. Ever since Darby Field first saw the White Mountains more than 270 years ago, they have drawn people to the area. The first explorers journeyed here on foot and in the saddle through the trackless forest; they were followed by the pathfinders of the region, the Crawfords, Rosebrooks, and Willeys, who established the first White Mountain inns, and were in turn succeeded by ever-increasing numbers of people seeking relief from the heat and dust of cities, willing to journey to this garden spot of Nature wherein settlements did not encroach. As we gaze northward, the line of division between the east and west side is the summit of the divide in the Crawford Notch.

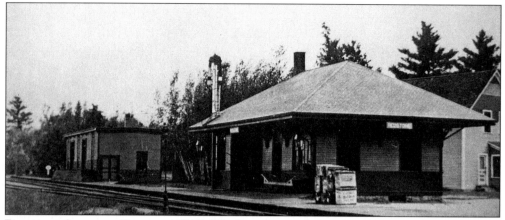

REDSTONE STATION, CONWAY, 1910. The Conways, including North Conway, Intervale, and Kearsarge, are considered the resort par-excellence of the section known as the "East Side" of the mountains.

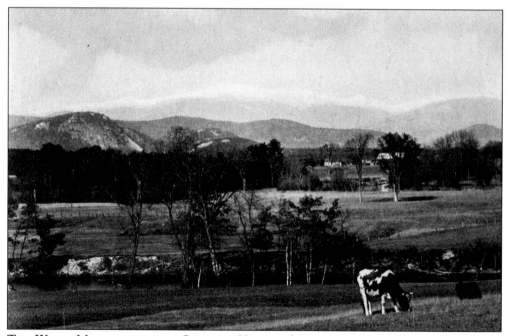

THE WHITE MOUNTAINS FROM CONWAY. Here, at the outer portal of the glorious gateway, may be seen the White Hills, the peaks of which stand out majestically across the Intervale.

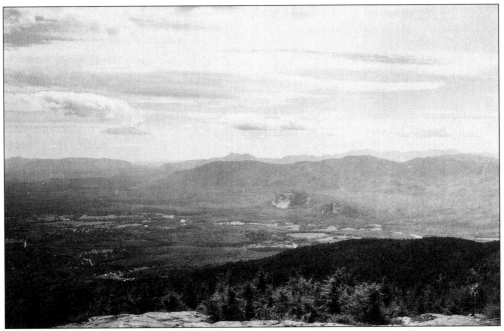

A Panorama of Cathedral Ledge from Kearsarge, which Lies South between Conway and North Conway. This massive ledge, a 700-foot near-vertical wall, was formed as result of granite shearing. The Echo Lake State Park lies along the floor of Cathedral Ledge.

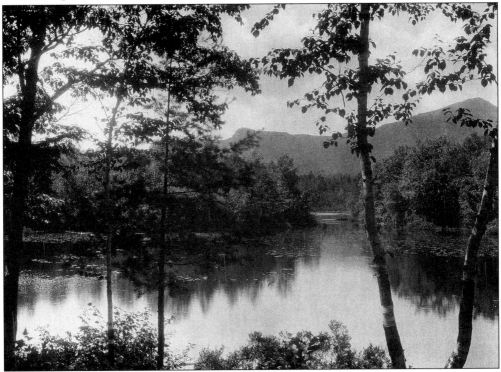

A Red Eagle Pond Vista Looking toward South Moat (alt. 2,770 feet) and Eagle Crag (alt. 3,030 feet).

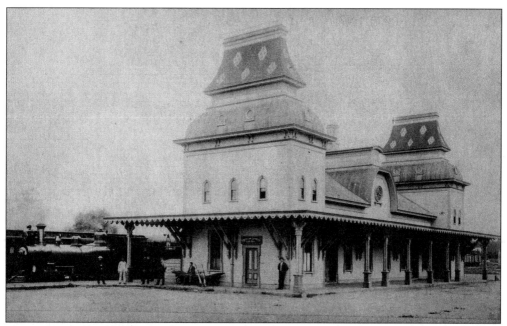

NORTH CONWAY STATION, NORTH CONWAY BRANCH, 1878. From this grand Victorian depot on Main Street, rail service is available to venture through Crawford Notch to Fabyan's at the base of Mt. Washington. Located at the station is the B&M *General Meade*.

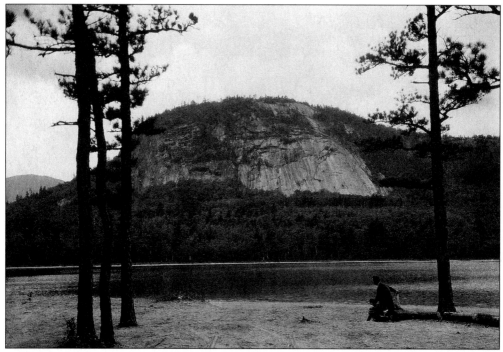

A VIEW OF WHITE HORSE LEDGE (ALT. 1,450 FEET), NORTH CONWAY. These remarkable cliffs, located on the west side of the Saco River, attract many seasonal visitors. It is recorded that the imaginative can trace the head and shoulders of a rearing horse, an image only visible from the Main Street of North Conway.

MOAT MOUNTAIN AND LEDGES (ALT. MIDDLE 2,805 FEET; NORTH 3,196 FEET; AND SOUTH 2,770 FEET), NORTH CONWAY, 1930s. These bluffs (spurs of the Moat Range) are also very popular with rock climbers, who ascend them via two principal trails—the White Horse Ledge trail and Bryce Path. The crest line of the ridge is about 3 miles long, consisting of the North and South peaks and several intervening rocky hammocks, separated by shallow ravines.

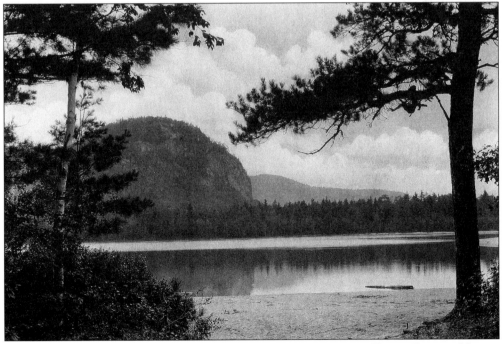

A VIEW ACROSS ECHO LAKE, LOCATED DUE EAST OF WHITE HORSE LEDGE, NORTH CONWAY. This lovely body of water might well be called Mirror Lake. It is exquisite at sunset when the waters are opalescent and the reflections of the trees and cliffs are inverted shadows. Almost sheer above the 14-acre lake is White Horse Cliff.

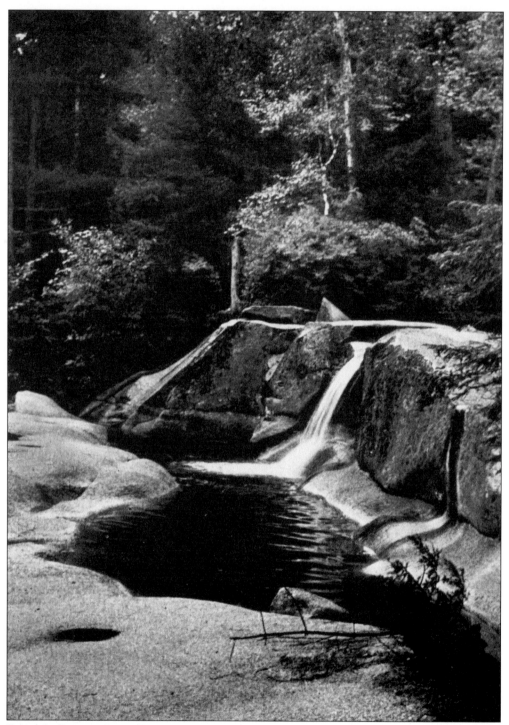

Diana's Baths, Lucy Brook, North Conway. Gently flowing over a table of granite, terminating by a beautiful fall some 10 feet in height, the stream plunges into a great number of holes (or basins) worn smooth by the action of the water. The largest of these, sparkling in the sunlight or quiet in the shadows, seems indeed to be a bath the goddess might use.

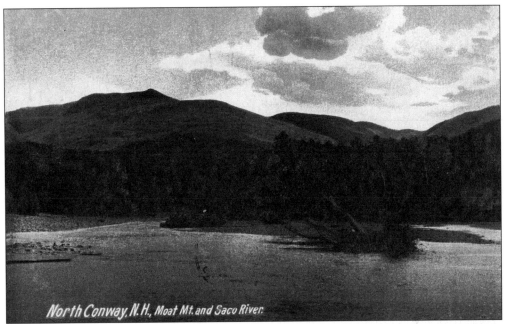

MOAT MOUNTAIN AND THE SACO RIVER, NORTH CONWAY, 1906. Marked trails to Middle Moat Mountain (alt. 2,805 feet), the central peak of the range, can be picked up at Diana's Baths.

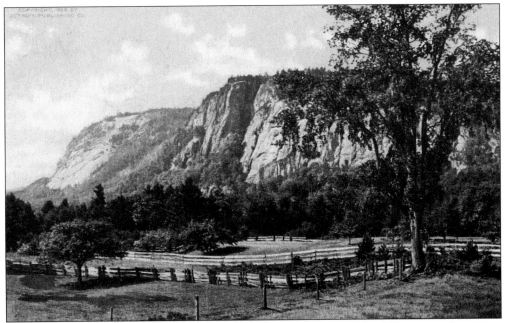

CATHEDRAL LEDGE (ALT. 1.159 FEET), NORTH CONWAY, 1908. This ledge received its name from the cathedral-like arch formed by the cliff. At the foot of the ledge is a small cave known as the Devil's Den. From here there is a steep dirt road to the top of Cathedral Ledge.

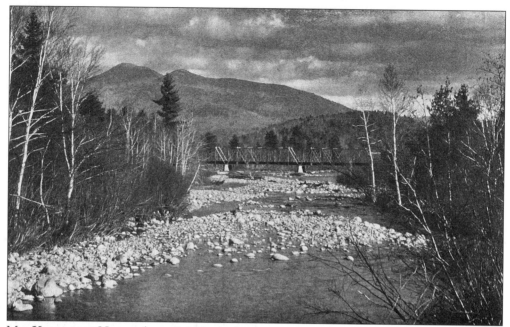

MT. KEARSARGE NORTH (ALT. 3,268 FEET) AND THE SACO RIVER, CONWAY. This mountain is sometimes referred to as Mt. Pequawket, rising above the Intervale. The summit bears an abandoned fire tower that is still in fairly good condition, and the views are spectacular in all directions. It is considered one of the finest viewing points in the White Mountains.

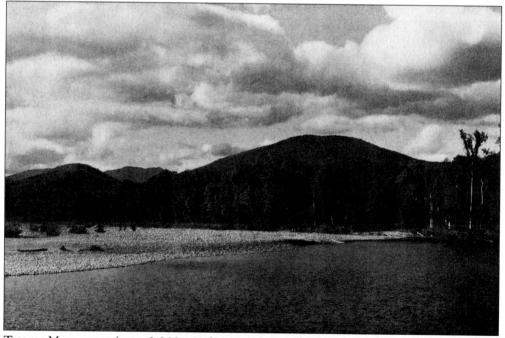

THORN MOUNTAIN (ALT. 2,282 FEET) AND THE SACO RIVER, BARTLETT. This mountain, with a forest-lined rocky knoll, rises at the south end of the ridge on which the lower eminence of Tin Mountain (alt. 2,031 feet) is located. There are but few mountains in this region, where the labor of ascent is so slight and the view of the Presidential so spectacular.

ARTIST'S FALLS, NORTH CONWAY, 1910.
This attractive combination of moss-
covered boulders and falling water has long
been a favored subject for artists. The
wooded path leads from the falls to Artists
Ledge, where a superb view can be had,
ranging from Peaked Mountain (alt. 1,739
feet) to Mt. Chocorua (alt. 3,500 feet) to
Mt. Washington (alt. 6,288 feet).

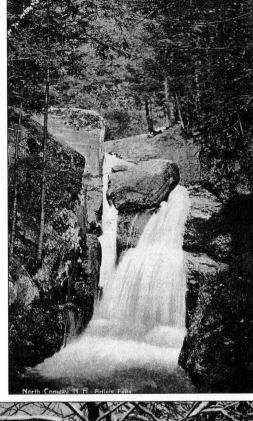

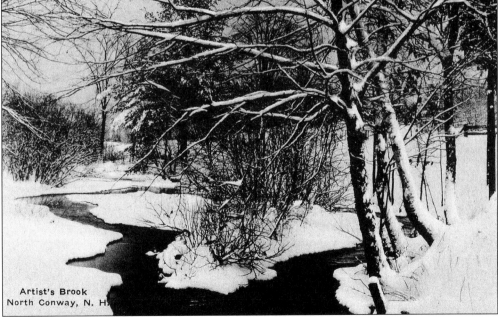

ARTIST'S BROOK, NORTH CONWAY, 1920. The lower reaches of Artist's Brook are more
beautiful, where it broadens out into a quiet and meandering course over the rich intervales,
among clusters of graceful elm trees, with noble views of the mountains on either side.

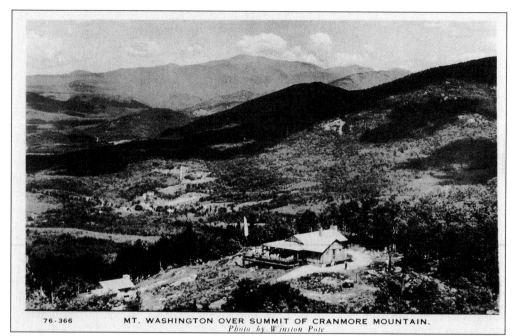

76-366 MT. WASHINGTON OVER SUMMIT OF CRANMORE MOUNTAIN.
Photo by Winston Pote

MT. WASHINGTON OVER THE SUMMIT OF CRANMORE MOUNTAIN (ALT. 1,690 FEET), 1940S. "Beyond these hills northward is daunting terrible, being full of rocky hills as mole hills in a meadow, and cloathed with infinite thick woods." —John Josselyn, 1672. In 1960, F. Allen Burt described the summit of Mt. Washington as "an arctic outpost in the midst of civilization." For more than 300 years, Mt. Washington has been the goal of adventurous climbers from every state in the Union and abroad.

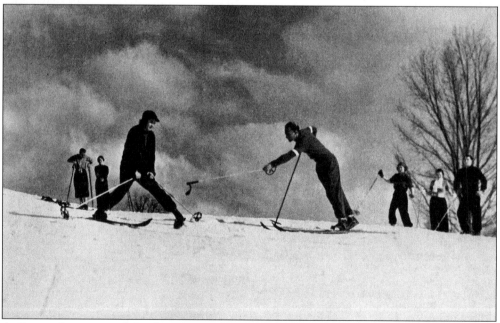

A SKIING LESSON ON MT. CRANMORE (ALT. 1,690 FEET), 1950S. Benno Rybiczka of the Eastern Slope Ski School is pictured here.

84

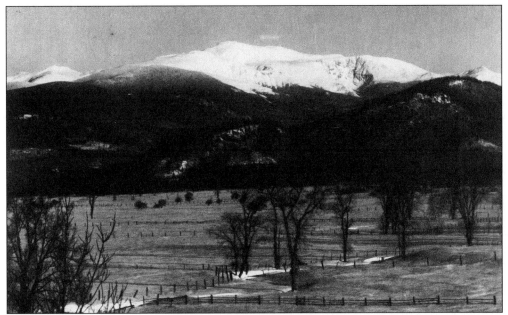

MT. WASHINGTON (ALT. 6,288 FEET) FROM INTERVALE. The most beautiful features of this area are the broad intervales of the Saco River, which spread a level floor of rich verdure from the foothills of the Presidential Range to the village terrace. About 16 miles distant is the peak of Mt. Washington, around which several of the other main mountains are clustered. Intervale's charm is in its surroundings, especially to the northwest, where the southern Presidential Range fills the horizon. One of the finest views in the entire region can be had from the center of this village.

INTERVALE (JCT.), 1909. Intervale Railroad Station served as the junction with the Intervale Path. Here the Boston & Maine systems ended, connecting it with the Maine Central Railroad line from Portland through Crawford Notch to Bretton Woods, Fabyans, and on to Lancaster, Colebrook, the Connecticut Lakes, Quebec, and, eventually, Montreal.

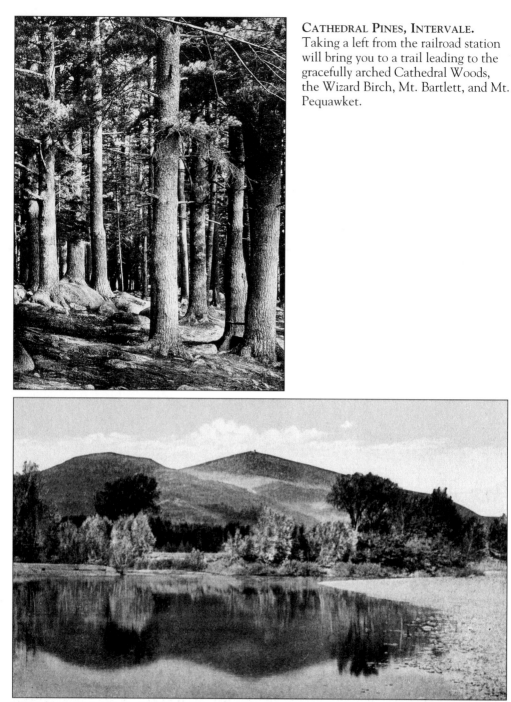

CATHEDRAL PINES, INTERVALE.
Taking a left from the railroad station will bring you to a trail leading to the gracefully arched Cathedral Woods, the Wizard Birch, Mt. Bartlett, and Mt. Pequawket.

MTS. BARTLETT (ALT. 2,661 FEET) AND KEARSARGE (ALT. 3,268 FEET) FROM THE SACO RIVER, NORTH CONWAY. The former, although a little more than half as high as Mt. Washington, commands a view that is but slightly inferior. Fine views of the ravines of the Presidential Range, as well as the ocean, can be plainly seen from the summit. Mt. Kearsarge, which is so often referred to as the sentinel of Crawford Notch, is the bright particular possession of this neighborhood.

GLEN AND JACKSON STATION, 1930. Jackson, so often referred to as "the ideal mountain village," is 8 miles above North Conway. A delightful village reached from the Glen Station on the Maine Central Railroad, it is the haunt of the artist and natural home of the lover of nature. From the station, Mt. Washington is approximately 16 miles north, and just next door are Pinkham and Carter Notches, Jackson Falls on the Wildcat, Goodrich Falls on Ellis River, Glen Ellis Falls, and Tuckerman's Ravine.

BARTLETT STATION, 1930. The Bartlett town line comes so close to the railroad at Intervale that Lower Bartlett seems part of North Conway.

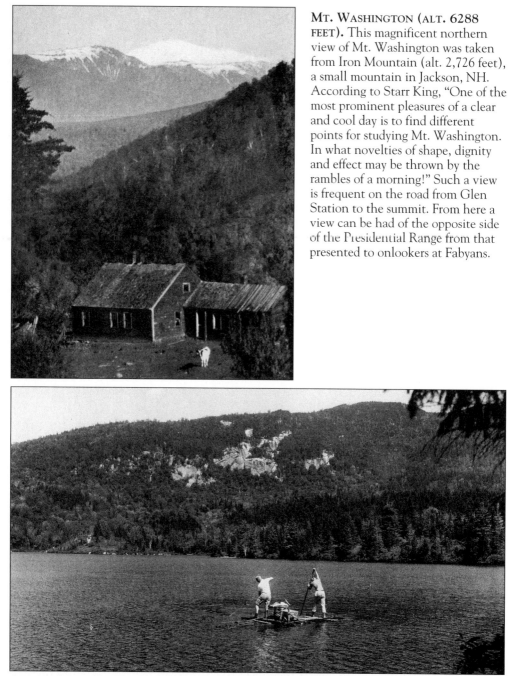

MT. WASHINGTON (ALT. 6288 FEET). This magnificent northern view of Mt. Washington was taken from Iron Mountain (alt. 2,726 feet), a small mountain in Jackson, NH. According to Starr King, "One of the most prominent pleasures of a clear and cool day is to find different points for studying Mt. Washington. In what novelties of shape, dignity and effect may be thrown by the rambles of a morning!" Such a view is frequent on the road from Glen Station to the summit. From here a view can be had of the opposite side of the Presidential Range from that presented to onlookers at Fabyans.

SAWYER POND (1,113 ACRES). This pond, sheltered on all sides by cliffs and mountain peaks, is nestled away from the rush of civilization in the towns of Livermore and Bartlett. It occupies a deep basin left by a retreating glacier. Forty-six acres in size, its crystal clear water reaches a depth of over 100 feet, with an average depth of 44 feet. The surrounding mountains are Tremont (alt. 3,371 feet), Owl Cliff (alt. 2,940 feet), and Green's Cliff (alt. 2,926 feet). Biologist Paul Hooper and a helper are shown here conducting the fish census of Sawyer Pond for the U.S. Fish and Wildlife Service, August 14–22, 1958.

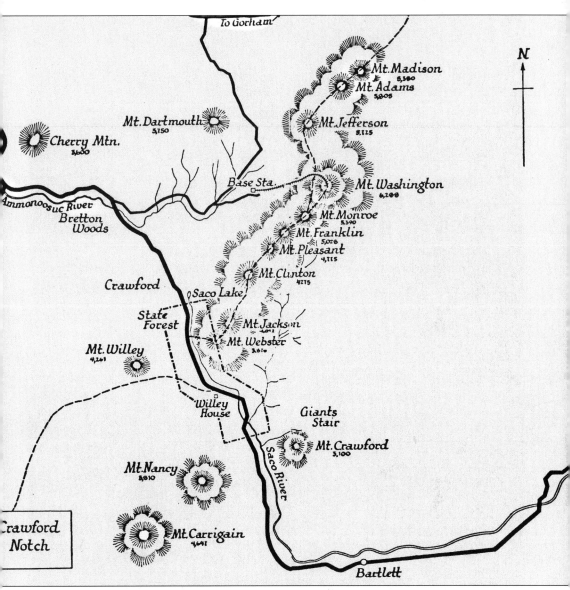

A MAP OF CRAWFORD NOTCH.

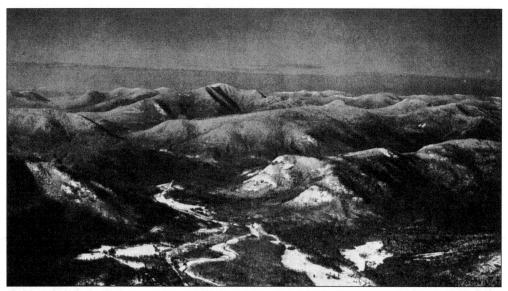

AN AERIAL VIEW OF THE SACO RIVER VALLEY, WITH BARTLETT VILLAGE IN THE CENTER FOREGROUND. The snow-covered outcrop in the center is Hart Ledge. On the left are the north slopes of Bartlett Haystack (alt. 2,713 feet) and Mt. Tremont (alt. 3,371 feet). Mt. Carrigain (alt. 4,700 feet) is the tall summit in the center background.

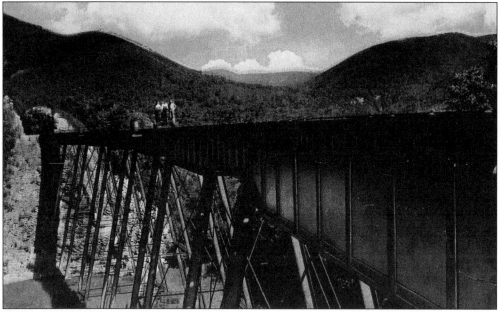

FRANKENSTEIN TRESTLE, CRAWFORD NOTCH. From Bemis Station the train climbs upward on a grade of one foot in 46, rushing through wilderness and clinging to the sides of the great cliffs. Just before the trestle is reached, vigilant travelers, looking forward on the right, will get one of the grandest views of Mt. Washington; this prospect has long been famed for its sublimity. Presently, the deep Frankenstein Gulf is crossed on the trestle of iron, 500 feet long and 80 feet high. After crossing the trestle, there is nothing but a shelf cut by the indomitable will of man from the mountainside for the passage of the train, ever increasing in altitude until the summit of the divide is reached.

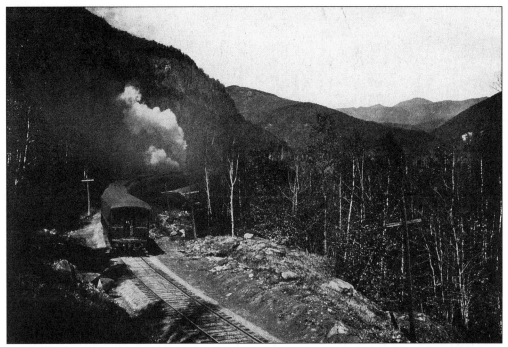

MT. WASHINGTON (ALT. 6,288 FEET) FROM FRANKENSTEIN. Five hundred feet above the Saco Valley, the train climbs the mountainside. Bordering the chasm on either side are lofty mountains surrounding this vantage point in the heart of Crawford Notch. Across the valley rises the avalanche-furrowed slope of Mt. Webster (alt. 3,910 feet). In front, the precipitous cliff of Mt. Willard (alt. 2,850 feet) appears to bar further progress, while farther up the notch, majestically grand at the head of a succession of peaks, appears Mt. Washington, "The Crown of New England."

SCENIC AUTO ROAD IN CRAWFORD NOTCH, EARLY 1900S. Below the train route in the Saco Valley was the main dirt thoroughfare for mountain visitors who wished to drive through the notch via a "modern" form of transportation.

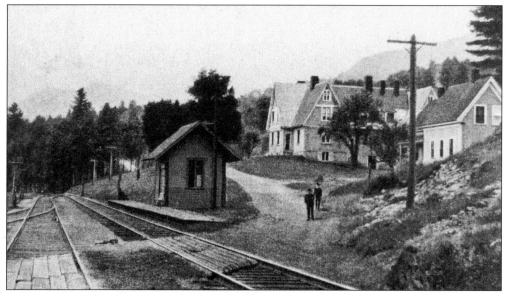

HART'S LOCATION, BEMIS HOUSE, 1908. This rich center of mountain scenery lies nearly in the center of Hart's Location, a division which includes the Saco Valley from Sawyer's Rock. The glen is between the mountains of the Crawford group on the east and the Nancy Range on the west, and was formerly occupied by valuable intervales that have been nearly ruined by slides and avalanches from Mt. Crawford. Nancy's Brook enters the Saco here from the west, and Sleeper Brook from the northeast. The railroad crosses the highway at Bemis Station, just south of which was the gabled cottage of Dr. Bemis, the patriarch of the mountain.

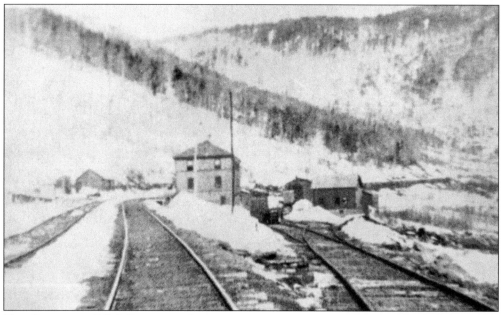

THE CARRIGAIN P&O RAILROAD STATION, 1890.

THE WILLEY HOUSE P&O RAILROAD STATION, 1905. This house burned in 1990.

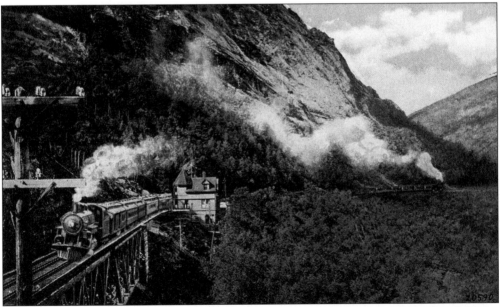

THE WILLARD HOUSE STATION, 1926. This station burned in 1974. The Willey Brook Bridge and Frankenstein Cliff (alt. 2,150 feet) are considered the heart of Crawford Notch. The notch is about 15 miles in length and 2 to 4 miles in breadth. The rail winds along the mountainside, passing over in its course two deep gorges, spanned by the Willey Brook Bridge and the Frankenstein Trestle, a triumph of engineering skill. Far down the valley lies the site of the Willey House, the scene of a terrible avalanche that, on August 28, 1826, blotted out the lives of the entire Willey family.

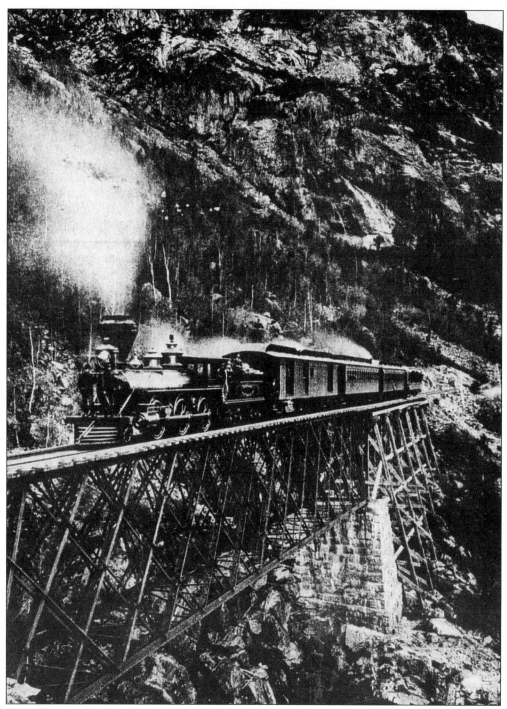

THE WILLEY BROOK BRIDGE AND A PORTLAND & OGDENSBURG RAILROAD TRAIN, SEPTEMBER 15, 1879. The successor to the stagecoach was the steam railroad, and New Hampshire pioneered in the use of steam for transportation. The coming of the railroads took place in the first half of the 19th century. Gradually, the Boston & Maine Railroad secured practically a monopoly, and by 1900 dominated the railroad mileage in the state.

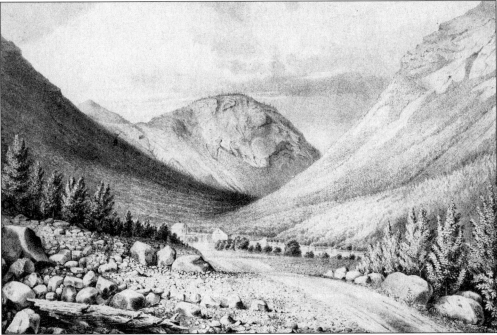

THE NOTCH OF THE WHITE MOUNTAINS, WITH THE WILLEY HOUSE, FROM A LITHOGRAPH BY B.W. THAYER & CO. The notch was discovered in 1771 by Timothy Nash, a Lancaster pioneer who, trailing moose up one of the ravines, noticed an old Native-American trail. It is named after Abel Crawford, who guided tourists through a scenic grandeur rarely equalled in the world. The 10th New Hampshire Turnpike ran through the notch northward to connect Coos County with Portsmouth, where local products were exchanged.

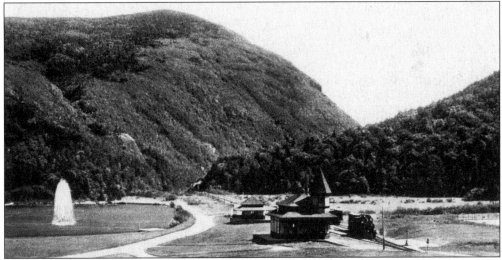

CRAWFORD NOTCH STATION, 1900. In 1803, Timothy Dwight rode through Crawford Notch on horseback and described it in the following manner: ". . . a very narrow defile extending two miles in length between huge cliffs . . . apparently rent asunder by some vast convulsion of nature. This convulsion was, in my own view, unquestionably that of the Deluge . . . The rocks, rude and rugged, were fashioned and piled on each other by a hand operating only in the boldest and most irregular manner."

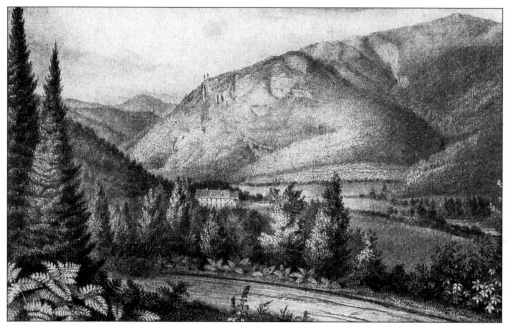

Mt. Crawford (alt. 3,119 feet) and Abel Crawford's House, in a Drawing by I. Sprague in Oakes' *White Mountain Scenery* (1848). This is the lowest but most alpine of the peaks of the Crawford group. It rises boldly from the Saco Valley, near the inflowing of the Mt. Washington River and Sleeper Brook, and exhibits a broad gulf on the side toward Bemis Station. A ridge runs south from Crawford along the east side of the Saco Valley to Hart's Ledge, around which the river bends to the east. The upper parts of Crawford are covered with broad red ledges, which render it easily recognizable from a distance.

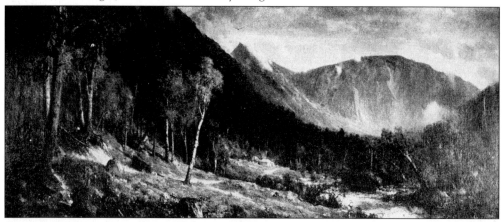

Crawford Notch, with the Willey House, Painted by Thomas Hill (1829–1908) in 1872. This house is frequented by visitors because of the tragedy that occurred here in 1826. The Willey House was built in 1793 as a public house on the Coos Road. In 1825, it was occupied by Samuel Willey Jr. and his family. In June 1826, two slides fell off the flank of Mt. Willey, near the house, premonitory of the coming disaster. On the night of August 28, 1826, a deluge of rain fell, washing out the sides of the ridges, flooding the valley, and inflicting great damage in all the adjacent towns. It is supposed that the family left the house in apprehension of the rising floods of the Saco, and retreated to a point farther up on the mountain, where they were overtaken by the avalanche and swept away to a fearful and united death.

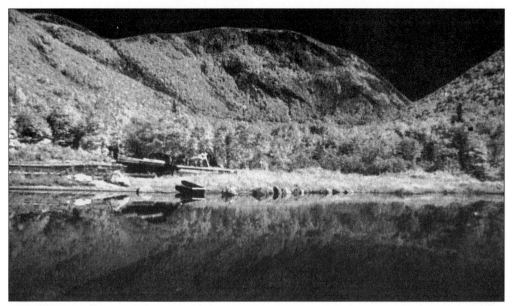

MT. WILLARD (ALT. 2,850 FEET) FROM THE WILLEY HOUSE IN AN INFRA-RED PHOTOGRAPH.
This mountain stands majestically in the mouth of the notch, between Mts. Field (alt. 4,340 feet) and Jackson (alt. 4,052 feet). It is not known for the mountainous panorama you may enjoy from Mts. Willey or Clinton, and its horizon is narrowed by the adjacent ranges, but its view has a singular beauty and quaint individuality that few others possesses. According to some accounts, this mountain was named for Professor Sidney Willard of Harvard University; other accounts claim it came it was named after Joseph Willard of Boston, MA, an enthusiastic admirer of the view.

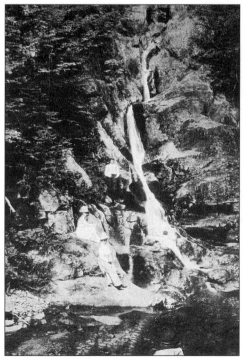

GIBB'S FALLS NEAR MT. CRAWFORD, A JUNIOR YOSEMITE. Here summer tourists enjoy a spring freshet as its rushes from the mountainside. This beautiful mountain stream tumbles down the west side of Mt. Pierce (alt. 4,310 feet), also known as Mt. Clinton, and along the historic Crawford path. The falls are so named for Colonel Joseph Gibbs, an early manager of the Crawford House and the Notch House.

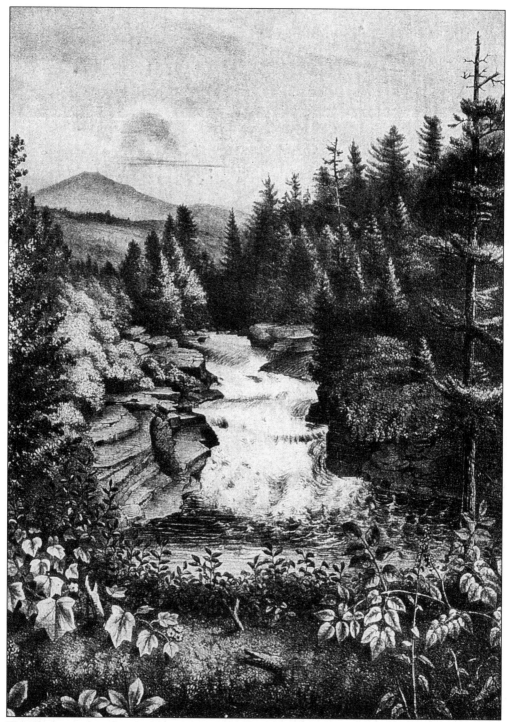

THE FALLS OF THE AMMONOOSUC NEAR CRAWFORD'S HOME, IN A DRAWING BY I. SPRAGUE FROM OAKES' *WHITE MOUNTAIN SCENERY* (1848). The stream descends over rapids and falls for nearly 50 feet, through a narrow gorge whose walls are polished ledges of granite. Below the plunge it whirls in white and billowy masses through a sinuous chasm between massive cliffs.

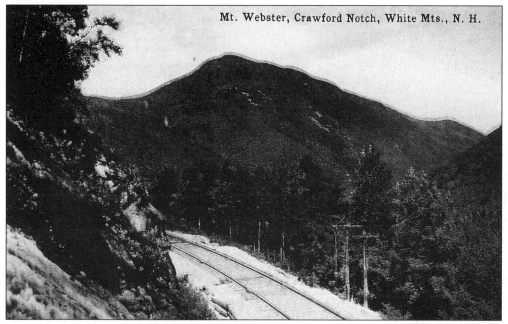

Mt. Webster, Crawford Notch, White Mts., N. H.

MT. WEBSTER (ALT. 3,910 FEET), CRAWFORD NOTCH. One of the finest views of the notch is where the bases of Mts. Willard (alt. 2,850 feet), Webster, and Willey (alt. 4,285 feet) approach each other. The descent through the notch is said to give a more marked impression of its grandeur than the ascent.

BEECHER'S CASCADE. This series of falls along the Crawford are named for Henry Ward Beecher, a clergyman from Brooklyn, NY, who summered at nearby Twin Mountain. Rev. Beecher would escape to the White Mountains to seek respite from hay fever, which afflicted him for up to six weeks each year.

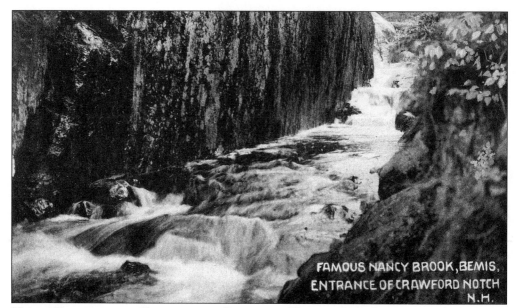

FAMOUS NANCY BROOK, BEMIS,
ENTRANCE OF CRAWFORD NOTCH
N.H.

NANCY BROOK AT THE ENTRANCE OF CRAWFORD NOTCH, 1909. It is written that a young girl, Nancy Barton, became engaged to a young man at her farm, but after leaving him her entire dowry, he abruptly abandoned her. Determined to find him, she followed him to the notch in the middle of the winter and discovered a campfire, cold and deserted. She continued her search until she became exhausted and fell beside the brook. A group of men from Jefferson went in search of her and found her frozen body in the snow. Her lover heard of her death and reportedly went insane and died a few years later. Tradition has it that her spirit still lingers in this valley.

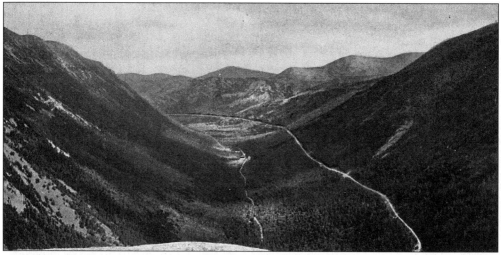

CRAWFORD NOTCH FROM MT. WILLARD. "The only way to appreciate the magnificence of the autumnal forest scenery in New England is to observe it on the hills. I never before had a conception of its gorgeousness. The appearance of the mountain-sides as we wound between them and swept by, was as if some omnipotent magic had been very busy with the landscape. It did not seem possible that all these square miles of gorgeous carpeting and brilliant upholstery had been the work of one week and had all been evoked, by the wand of frost, out of the monotonous green which June had flung over nature." —Starr King, *The White Hills*.

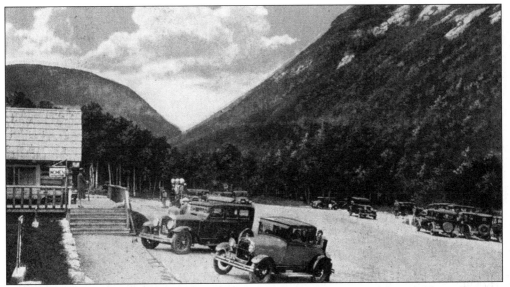

CRAWFORD NOTCH AND MT. WILLARD (ALT. 2,850 FEET) FROM THE WILLEY HOUSE CAMPS, 1931. "When we entered the Notch we were struck with the wild and solemn appearance of everything before us. The scale, on which all the objects in view were formed, was the scale of grandeur only. The rocks, rude and ragged in a manner rarely paralleled, were fashioned and piled on each other by a hand operating only in the boldest and most irregular manner. As we advanced, these appearances increased rapidly. Huge masses of granite of every abrupt form rose to a mountainous height. Before us, the view widened fast to the southeast. Behind us it closed almost instantaneously; and presented nothing to the eye but an impossible barrier of mountains." —Dwight's *Travels in New England*.

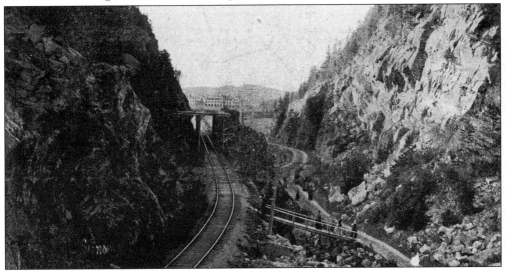

THE GATE TO "THE NOTCH." This deep pass through the mountains, dividing the great New Hampshire group near its center, is approximately 3 miles long, extending from the Gate to a little below the Willey House. It lies between Mt. Willard on the west and Mts. Webster and Jackson on the east. The valley from Lower Bartlett to the Willey House is narrow and mountain ranges rise boldly on either side, thus forming an appropriate approach to the narrow gorge beyond.

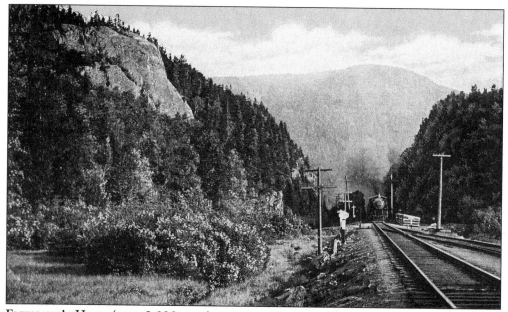

ELEPHANT'S HEAD (ALT. 2,020 FEET) AND THE GATE TO CRAWFORD NOTCH. Just beyond the site of the old Crawford House, towering 100 feet above the Carriage Road, is a huge boulder, shaped not unlike the head of an elephant, the trunk of which reaches to the roadway. A few yards to the right, the railroad emerges through a great cut in the mountainside.

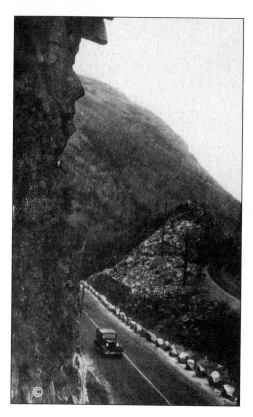

THE ROMAN WARRIOR AND THE ENTRANCE TO CRAWFORD NOTCH, 1939. This passage is often called the Upper Gateway. Between the narrowly separated mountain walls, the railroad, the Carriage Road, and the infant waterway, Saco, struggle for a passage. Here, the Saco has not yet earned its title of river, being fresh from its source in the clear lake that fronts the former Crawford House. The Carriage Road dips smoothly down into the bowl-like Crawford Notch from this point until it reaches the bottom of the valley, where it follows the ever-growing Saco through to Bartlett. The railroad follows far above the tree tops on a high ledge cut for its passage.

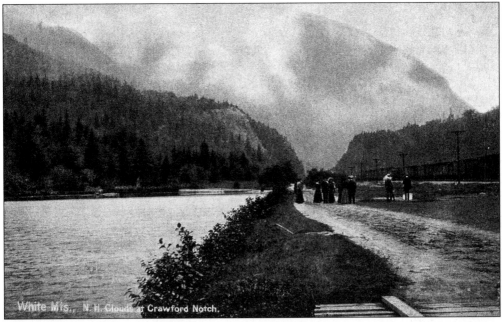

CRAWFORD NOTCH ROAD, 1920S.

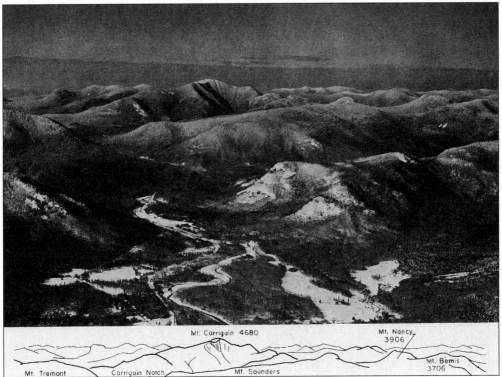

AN AERIAL VIEW OF THE SACO RIVER VALLEY WITH MT. CARRIGAIN IN THE CENTER BACKGROUND. This area was first explored in the mid-1700s by trappers. Lumbering started in 1884 with the building of a logging railroad through the valley, and during the following years, a 50-mile steam railroad system was developed.

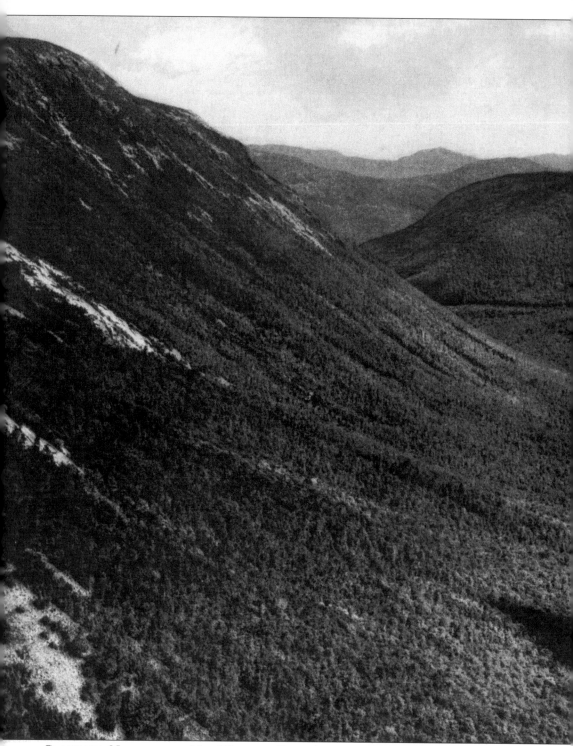

CRAWFORD NOTCH FROM MT. WILLARD. From this vantage point the entire magnificent panorama of Crawford Notch can be seen. Note the railroad winding down through the wild valley, precariously clinging in places to the almost perpendicular sides of the mountain. In the

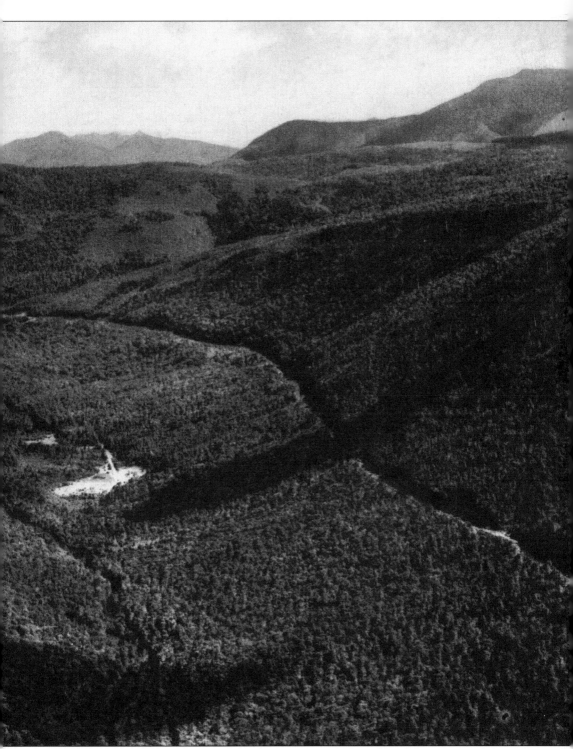

(middle) distance the old Willey House used to stand, built to furnish food and shelter to passing teamsters who were hauling freight by sleds to and from Portland, ME.

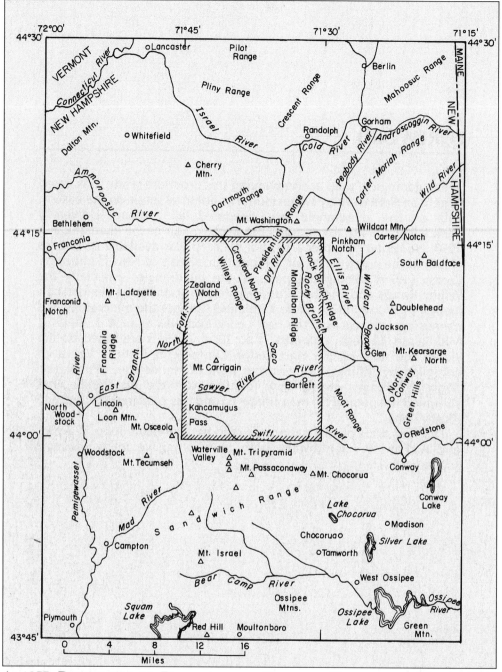

A 1977 Department of Resources and Economic Development Map of the Crawford Notch Quadrangle.

Five

THE CARTER RANGE AND PINKHAM NOTCH

THE PINKHAM NOTCH ROAD IN 1912. Pinkham Notch must have been known as early as 1774, since Captain Evans started building a road through it in that year. It was named for Joseph Pinkham, who settled in the present town of Jackson in 1790. The leading pioneers of Pinkham Notch, or the Glen as it is now called, were the Copps, who came in 1831. The name of matron Dolly Copp has been given to a popular camping ground north of the Glen House.

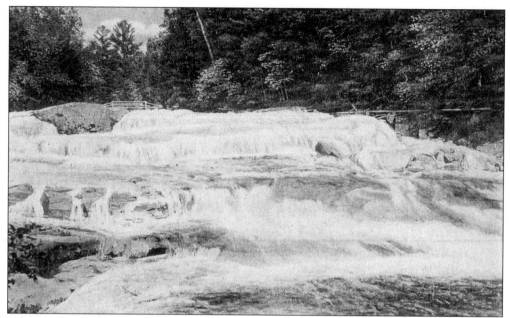

JACKSON FALLS, JACKSON. Less than 4 miles from the Glen Railroad Station is a beautiful and secluded glen with a series of romantic cascades on the Wildcat, a tributary of the Ellis River, enwalled on all sides by dark green mountains and rocky-faced peaks.

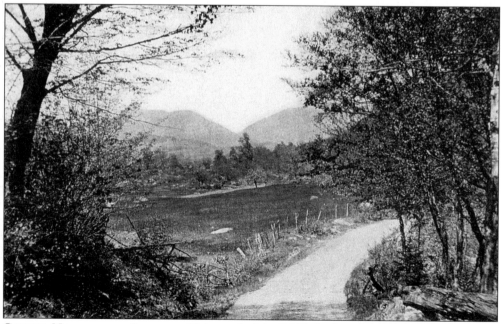

CARTER NOTCH FROM JACKSON. This notch (alt. 3,388 feet), a deep cleft between Carter Dome (alt. 4,832 feet) and Wildcat Mountain (alt. 4,422 feet), includes some of the finest scenery in the White Mountains.

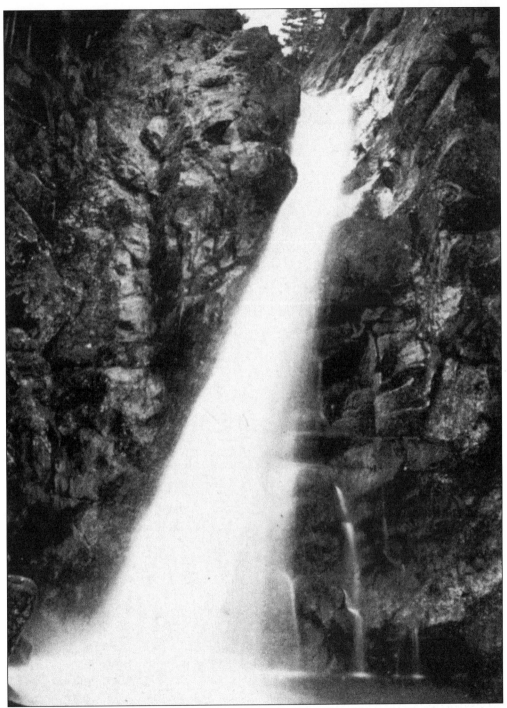

GLEN ELLIS FALLS. The falls are about 4 miles south of the Glen House on the North Conway Road and are reached by a .25-mile walk from the highway. The main fall, which descends through a deep groove worn in the rocks, is 70 feet in height, and is considered by many to be the finest in the White Mountains. These falls are located on the Ellis River at the base of Wildcat Mountain, whose formidable ridges tower above to great heights.

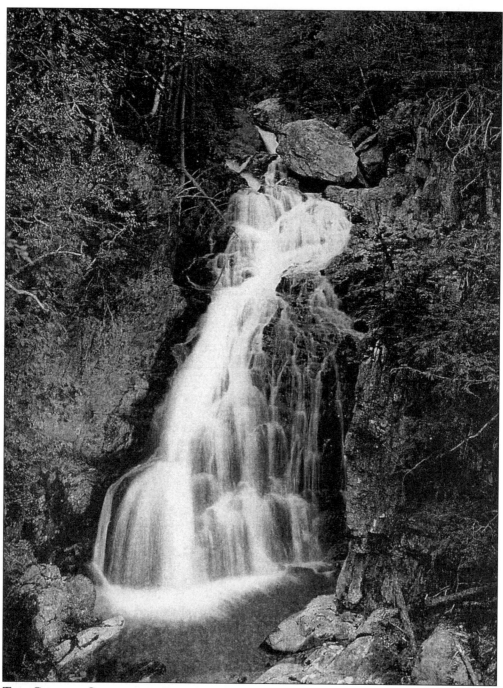

THE CRYSTAL CASCADE IN PINKHAM NOTCH. The 80-foot fall over successive step-like terraces of slaty rocks, crossed by igneous dikes, is located on the Ellis River, below the outlet of Tuckerman's Ravine on the west side of the Pinkham Notch. During high-water periods it affords a brilliant sight, but at other seasons the stream dwindles away into white threads of water.

CARTER DOME (ALT. 4,832 FEET)
VIEWED FROM WILDCAT MOUNTAIN,
1965. Properly speaking, this range of
mountains extends from the
Androscoggin Valley to Carter Notch,
including Mts. Moriah, Imp, Carter, and
Hight. In a narrower sense it includes
that portion of the ridge between the
Imp and the notch; the name of Mt.
Carter is applied only to the peaks nearly
behind the Glen House.

R.A. SKINNER, NO 55, RACING IN THE
AMC INVITATION SKI RACE ON
WILDCAT MOUNTAIN, MARCH 14,
1937.

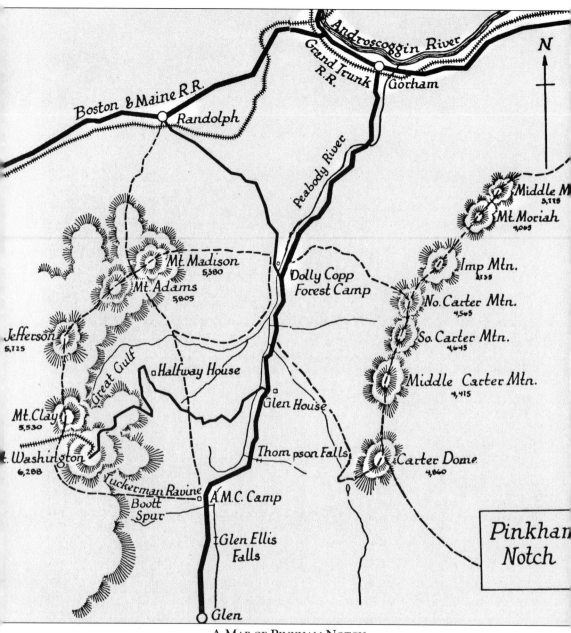

A Map of Pinkham Notch.

THE BOOTT SPUR (ALT. 5,500 FEET) FROM THE HUNTINGTON RAVINE TRAIL. The great southeast shoulder of Mt. Washington forms the south wall of Tuckerman Ravine and the north wall of the Gulf of Slides. The flat ridge connecting Boott Spur with the cone of Mt. Washington bears Bigelow Lawn, the largest of the Presidential Range lawns.

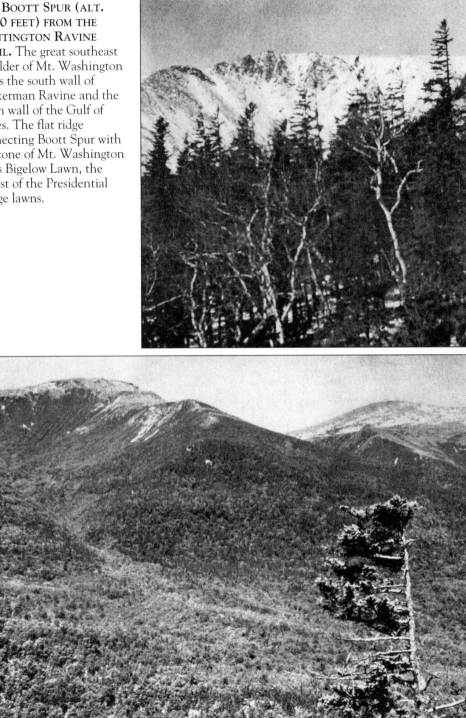

THE BOOTT SPUR (ALT. 5,500 FEET). This ridge is named in honor of Dr. Francis Boott, a physician and botanist who explored the Presidential Range during the early 1800s with Dr. Jacob Bigelow.

THE CARTER-MORIAH RANGE IN WINTER FROM THE GULF OF SLIDES, 1950. The Carter-Moriah Range is frequently approached from the Nineteen Brook Trail or from the Glen House, where a branch of the trail leads to Carter Notch and an Appalachian Mountain Club Hut. From this point trails lead to all the peaks in the chain as well as the Presidential Range.

THE PINKHAM NOTCH CAMPS, AMC.

AUTOMOBILES PARKED ALONG THE PINKHAM NOTCH ROAD NEAR THE AMC TRADING POST, MARCH 10, 1940.

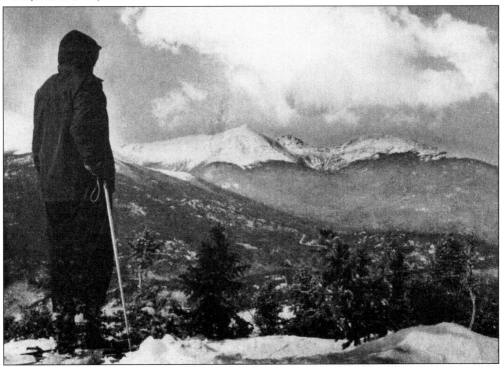

MT. ADAMS (ALT. 5,799 FEET) AND MT. MADISON (ALT. 5,366 FEET) FROM WILDCAT MOUNTAIN. It is recorded that Professor Arnold Guyot gave this mountain its name, for he claims that wildcats were seen here. Earlier it was known as East Mountain due to its location, east of Pinkham Notch; it has also been called Mt. Hight.

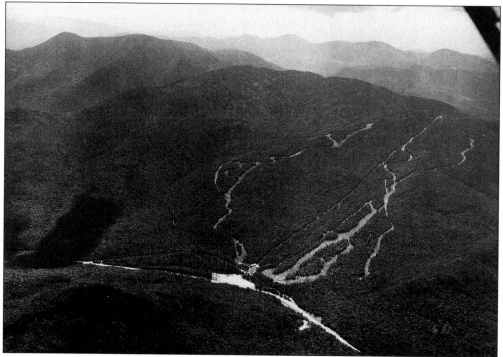

AN AERIAL VIEW OF THE WILDCAT RECREATIONAL AREA (ALT. 2,850 FEET) WITH THE CARTER-MORIAH RANGE IN THE BACKGROUND, 1962. Wildcat Mountain is south of the Glen House, between Carter Notch and Pinkham Notch, with spurs running south into Jackson. It was named East Mountain on Belknap's Map of 1791, due to its position in relation to Pinkham Notch.

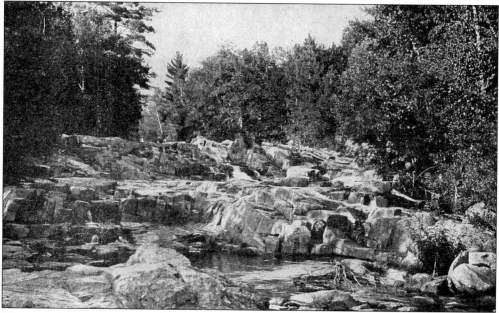

WILDCAT RIVER, JACKSON. From this mountain the beautiful cascading Wildcat River tumbles into the town of Jackson.

THE DOLLY COPP CAMPGROUND, 1950S. This camp was named for Dolly Copp, an early pioneer and character of the region. Dolly Copp, nee Emery, is one of the few women whose names have come down from pioneer days in these mountains. It offers the best view of the Imp face on Imp Mountain (alt. 3,735 feet), one of the peaks of the Carter Range, which dominates the east. The campground is maintained by the U.S. Forestry Service, and is considered the most popular of New Hampshire's many camps.

IMP MOUNTAIN (ALT. 3,730 FEET) AS SEEN FROM THE DOLLY COPP CAMPGROUND, 1960. The Imp is "a grotesque sphinx" that appears on one of the peaks of the Carter Range, the profile being formed by the upper crags of Mt. Imp. It has a weird resemblance to a distorted human face. It is best observed during the late afternoon from Copp's Farm of the Glen House, on the old road to Randolph west of the Peabody River.

A WILD DEER HUNTING FOR FOOD IN THE WINTER.

CAMPERS ALONG THE PEABODY RIVER, DOLLY COPP CAMPGROUND, 1930s.

Six

MT. CHOCORUA AND THE SANDWICH MOUNTAIN RANGE

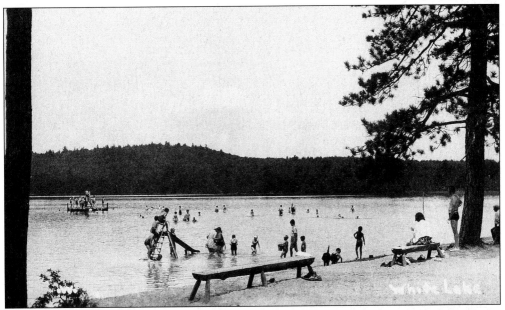

WHITE LAKE STATE PARK, TAMWORTH, LOOKING WEST WITH THE SANDWICH MOUNTAIN RANGE IN THE BACKGROUND. The Sandwich Range crosses the southern portion of the White Mountain National Forest between Conway and Plymouth. This range bears the names of Native-American chiefs, including Passaconaway, Wonalancet, Kancamagus, Paugus, and Chocorua, who ruled the land when the first white settlers came.

THE OSSIPEE STATION, 1898. With beautiful Lake Winnipesaukee to the southwest and wondrous Crawford Notch at its northern extremity, we continue our adventure via rail and road across the Sandwich Mountain Range to the Pemigewasset.

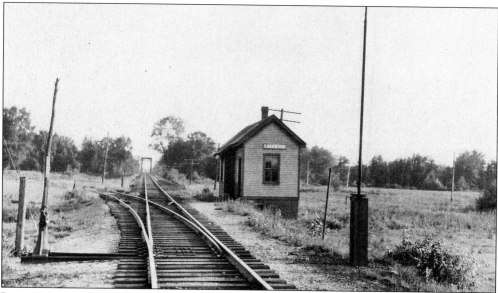

LAKEWOOD STATION, WEST OSSIPEE, 1910.

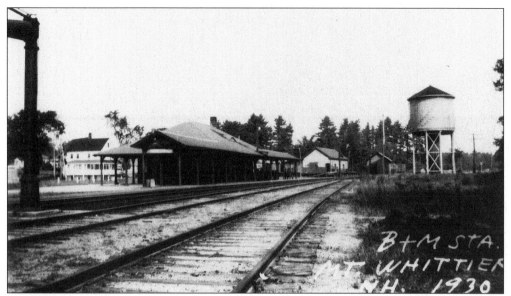

MT. WHITTIER STATION, WEST OSSIPEE, 1930. This station is located on the east side of the Ossipee Range, from which there is a fine view overlooking Lake Winnipesaukee to its west. Both the settlement and Mt. Whittier are named for poet John Greenleaf Whittier, who spent many summers here and wrote numerous poems about the mountains and rivers of the region.

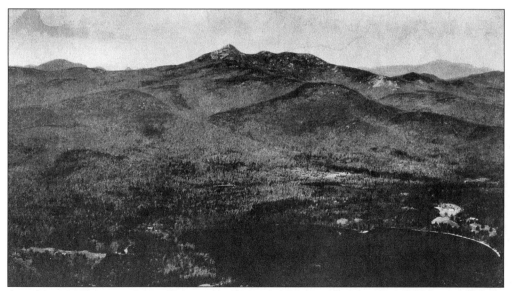

AN AERIAL VIEW OF MT. CHOCORUA (ALT. 3,500 FEET), LOOKING WEST OVER LAKE CHOCORUA. Both lake and mountain are named after Chief Chocorua of the Pequawket Indians. Many legends have been written concerning this famous chief and his curse on the white settlers of the valley: "May the Great Spirit curse you when he speaks in the clouds and his words are fire! Lightning blasts your crops! Wind and fire destroy your homes! The evil One breathe death on your cattle! Panthers howl and wolves fatten on your bones!"

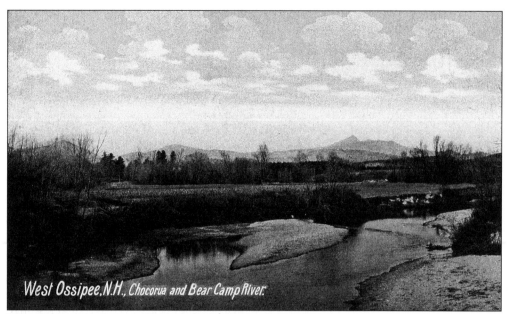

West Ossipee, N.H., Chocorua and Bear Camp River.

MT. CHOCORUA (ALT. 3,500 FEET) AND BEAR CAMP RIVER AS SEEN FROM WEST OSSIPEE, 1930S. Here the river flows close to the base of the Ossipee Mountains, bordered by pleasant meadows and graceful trees. The scenery encompasses the Ossipee Range, the Green Mountains of Effingham, the picturesque peaks of the Sandwich Range, the alpine-crested Chocorua, the lower ledges of Mt. Paugus (alt. 3,198 feet), the dark round top of Passaconaway (alt. 4,043 feet), the shining cliffs of Whiteface (alt. 4,020 feet), and the forest-covered Sandwich Dome (alt. 3,980 feet).

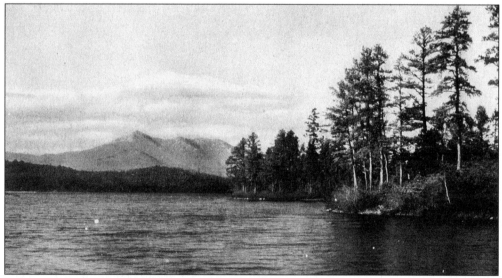

SILVER LAKE (WHITE LAKE), MADISON, WITH MT. CHOCORUA IN THE DISTANCE. These shores were favorite grounds for Native Americans, as is evident by the many relics found here. Glowing in sunset splendor, streaked with all the hues on the rainbow, the lake is indeed magnificent. As the sun glides down in the west, a ruddy glow tinges Chocorua's pinnacle, while the shadows lurking in the ravine and lake steal darkly up the mountainside and crouch for a final spring upon the summit.

SWIFT RIVER AND MT. CHOCORUA.
Paradise seems to have opened wide its
gates to the northern White Hills. We
stand spellbound with a strange, exquisite
feeling when the voice of the river breaks
the solemn stillness of this almost
supernatural vision. The picturesque
cone of Mt. Chocorua is located at the
east end of the Sandwich Mountain
Range. It is unquestionably one of the
most frequently photographed mountains
in the world, and one of the most popular
peaks for climbers. The Sandwich
Mountain Range is a combination of
mountains and ridges that extend west
from the Conways on the Saco River to
Campton on the Pemigewasset for
approximately 30 miles.

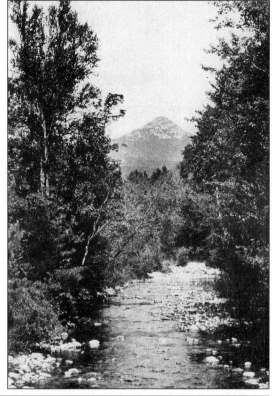

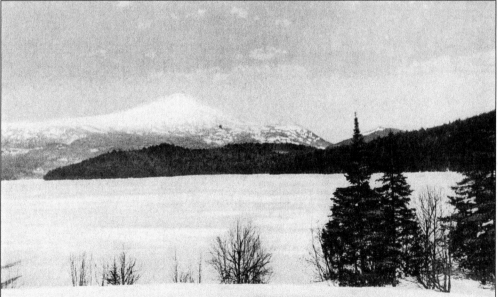

WHITEFACE MOUNTAIN (ALT. 4,020 FEET) IN WINTER. This mountain no doubt received its
name from the precipitous ledges south of its summit, which affords a magnificent view from the
bare ledge at its top. Low lesser ridges run south on either side of the cliff, while the backbone
of the mountain travels north, connecting it with Mt. Passaconaway. On the northwest,
Sleeper Ridge connects Whiteface to Mt. Tripyramid.

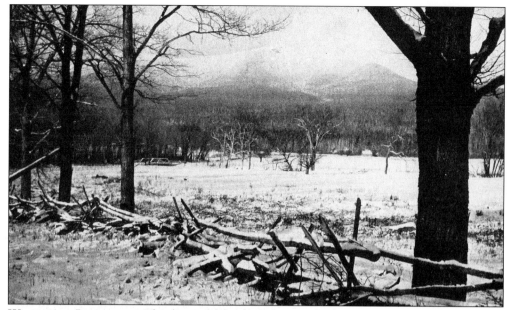

WHITEFACE INTERVALE. This beautiful landscape, near the base of Whiteface Mountain, is located about 3 miles north of the western junction of NH 113 and NH 113A, where NH 113A turns from north-south to east-west. "So lovingly the clouds caress his head, the Mountain-monarch; he, severe and hard, with white face set like flint horizon-ward; they weaving softest fleece of gold and red. And gossamer of airest silver thread, to wrap his form, wind-beaten, thunder-scarred." —Lucy Larcom's *An Idyl of Work.*

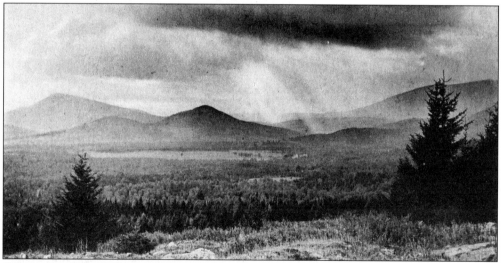

SANDWICH DOME (ALT. 3,980 FEET) FROM MT. KATHERINE (ALT. 1,380 FEET), WONALANCET. This immense mountain in the western part of the towns of Sandwich and Waterville is separated from the Campton Range by Sandwich Notch, and from Whiteface by the low plateau of Flat Mountain (alt. 2,940 feet). It is known to many in adjacent towns as Black Mountain, a name that has been given to its southwest spur (alt, 3,500 feet), a ledgy outlook, and to Nubble (alt. 2,732 feet), located at the end of the spur. However, since this name has been applied to so many summits in New Hampshire, Professor Guyot bestowed upon it the name "Sandwich Dome," which has been accepted by the State Geological Survey.

124

FALLS OF THE BEARCAMP KNOWN AS BEEDE FALLS (COW FALLS) IN SANDWICH NOTCH. This very secluded falls is located 3.4 miles from the quiet village Center Sandwich. The waters travel southeast to become part of the Bearcamp River.

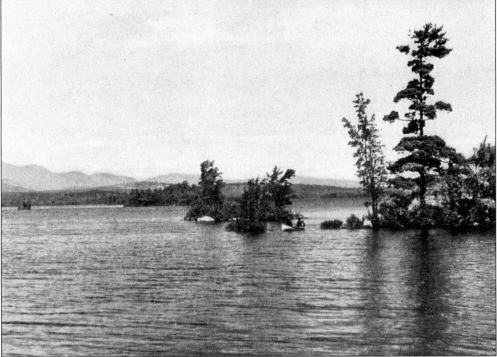

AMONG THE ISLANDS, SQUAM LAKE, HOLDERNESS, WITH THE SANDWICH MOUNTAIN RANGE IN THE BACKGROUND.

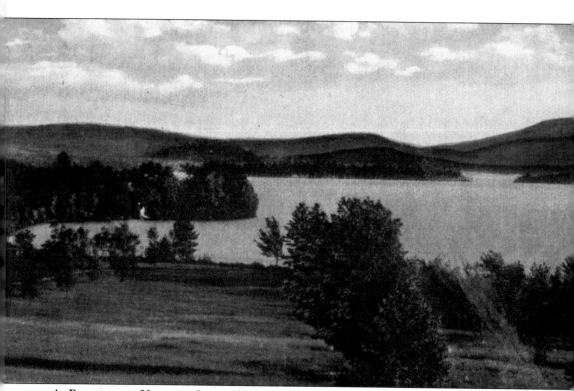

A PANORAMIC VIEW OF LAKE WINNIPESAUKEE LOOKING NORTHEAST FROM GILFORD.
Rattlesnake Island is on the right with the Ossipee Mountain Range in the background.
Nothing can exceed the beauty of the mountains on the north shore; they are the Ossipee,
Sandwich, and Presidential Ranges in the White Mountains framing the water's edge. New
Hampshire's largest lake has an area of 72 square miles, a mainline shoreline of 186 miles, is
dotted with 274 habitable islands, and is surrounded by the foothills of the White Mountains.
The water of this lake empties into the Winnipesaukee River, which soon forms a junction with

the Pemigewasset River; the two rivers unite making the Merrimack River at Franklin Falls, NH. The Native-American entomology of the name Winnipesaukee is "winni," meaning "beautiful,"; "nippe," meaning "water"; "kees," meaning "high"; and "uhki," meaning "place." Thus, "Winni-nippe-kees-uhki" means "The beautiful water (in the) high place." The popular definition of the name in New Hampshire is "The smile of the Great Spirit," but it has no relation whatsoever to its entomology.

SQUAM LAKE (LEFT), THE RATTLESNAKES (CENTER), AND DOUBLEHEAD (ALT. 2,158 FEET), HOLDERNESS. The limpid purity of the water and the grandeur of the adjacent mountains combine to make this rich fascinating panorama. The lake's Native-American name is said to have been either "Wonn-as-squam-auke," meaning "the beautiful surrounded-by-water place," or "Kee-see-hunk-nip-ee," meaning "the goose-lake of the highlands." It is surrounded by high, plush, green hills, and drains not into neighboring Lake Winnipesaukee, but into the Pemigewasset River. Twenty-six islands dot its surface.

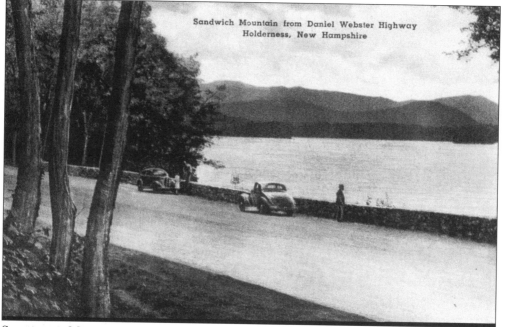

SANDWICH MOUNTAIN (ALT. 3,980 FEET) FROM THE DANIEL WEBSTER HIGHWAY, HOLDERNESS, 1920s.